David Bellamy's
Skies, Light &
Atmosphere
IN WATERCOLOUR

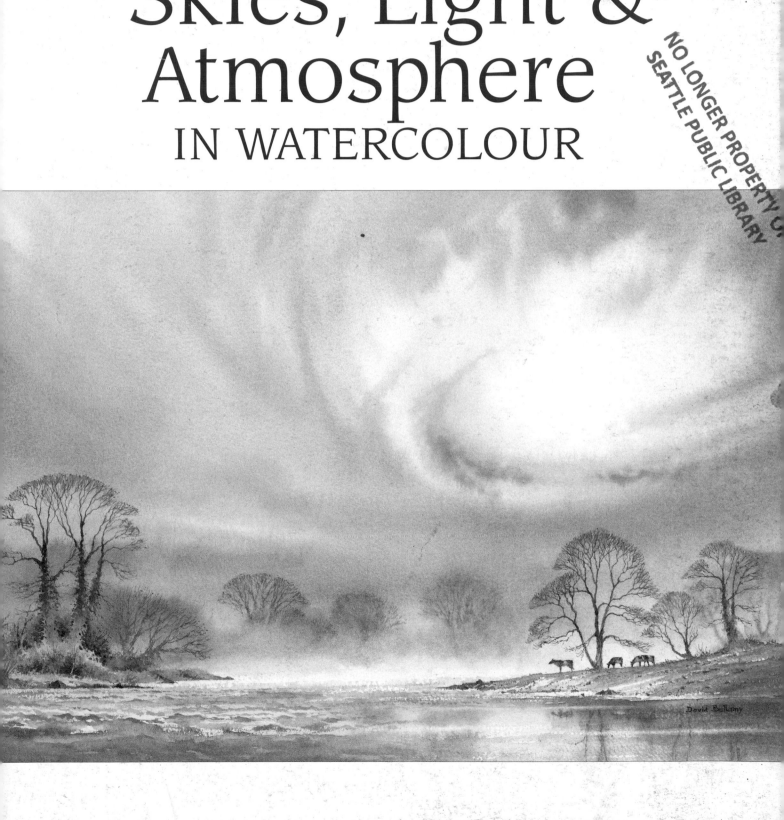

David Bellamy

Dedication

To Jo, who always comes up with a hearty quip even in the direst of adversities.

David Bellamy's
Skies, Light &
Atmosphere
IN WATERCOLOUR

SEARCH PRESS

First published in Great Britain 2012

Search Press Limited
Wellwood, North Farm Road,
Tunbridge Wells, Kent TN2 3DR

Illustrations and text copyright
© David Bellamy 2012

Photographs by Debbie Patterson at
Search Press Studios

Photographs and design copyright
© Search Press Ltd. 2012

ISBN: 978-1-84448-677-9

The Publishers and author can accept no
responsibility for any consequences arising from
the information, advice or instructions given in
this publication.

Suppliers
If you have difficulty in obtaining any of the
materials and equipment mentioned in this book,
then please visit the Search Press website for
details of suppliers: www.searchpress.com

Publisher's note
All the step-by-step photographs in this book
feature the author, David Bellamy, demonstrating
his watercolour painting techniques. No models
have been used.

You are invited to visit the author's website
and blog:

www.davidbellamy.co.uk

http://davidbellamyart.blogspot.com

Printed in Malaysia

Acknowledgements

*I am indebted to Jenny Keal for checking my manuscript
and Sophie Kersey who edited this book.*

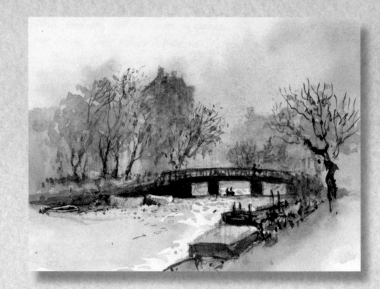

Front cover
**Detail from Sunset,
Carreg Cennen**
30 x 45cm (11¾ x 17¾in)

Page 1
**Morning Mist,
River Wye**
27 x 40cm (10⅝ x 15¾in)

Pages 2–3
Sunset, Carreg Cennen
30 x 45cm (11¾ x 17¾in)

Above
Canal in Amsterdam

Opposite
**Evening Light,
Landshipping**
28 x 42cm (11 x 16½in)

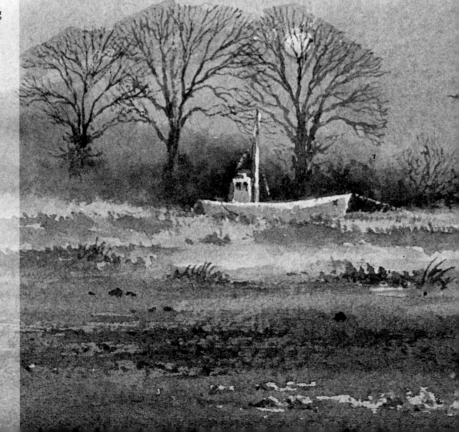

Contents

Introduction

For the landscape painter, skies, light and atmosphere are all inextricably bound together, and to fuse these elements into a sense of empathy with the scene being painted will enhance your painting considerably. In this book I aim to show you how to add that vital ingredient into your work with various techniques and devices. However good your composition may be, it will fall short if it lacks the passion and inspiration with which these three ingredients can enrich your work. Even the most mundane of subjects can be transformed by the right lighting and mood, so whatever you may wish to paint, the techniques you find here will greatly enhance your paintings. You will find a wide variety of scenery and seasons, and a whole range of different skies to try out. One of the advantages of being able to render a large selection of skies, moods and various forms of lighting is that you can paint the same subject time and time again in a completely different way, so this will provide you with many excellent ideas for tackling your favourite subjects.

Many artists find themselves in a rut from time to time, unable to generate enthusiasm for the next painting. By taking your sketch or photograph of the scene and considering some of the methods for creating or changing the sky, lighting or atmosphere that you find in this book, you can come up with a truly fresh look at the landscape. Take some of my examples of all three of these elements and superimpose them on to your own subjects. Try out different approaches on the same scene. So often we

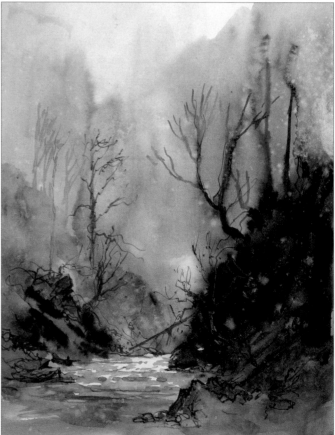

Bachowy, Wales, in rain

To really get to grips with capturing atmosphere, you need to get outside in all weathers. This messy sketch, carried out on cartridge paper using watercolour and dark watercolour pencils, was done in a few minutes in falling rain – the effects of the raindrops are clearly visible. By drawing into the wet washes with watercolour pencils, I was able to retain the image, even if the colours went awry.

come across truly stunning scenery bathed in the dullest of light that gives us precious little inspiration, but the techniques in the following pages should help you to inject some excitement into your watercolours, even when it is not present in the original scene. You will quickly find yourself weighing up the composition you are about to paint, in terms of what sort of sky, mood and lighting conditions will work best in each particular painting.

Moody Mountain, Snowdonia
17 x 23cm (6¾ x 9in)

The inter-relationship between skies, light and atmosphere is shown in this watercolour, where the moody peaks and crags run into the sky area and the light is concentrated in certain parts of the composition. In places it is almost impossible to judge whether a shape is a mountain peak or a cloud.

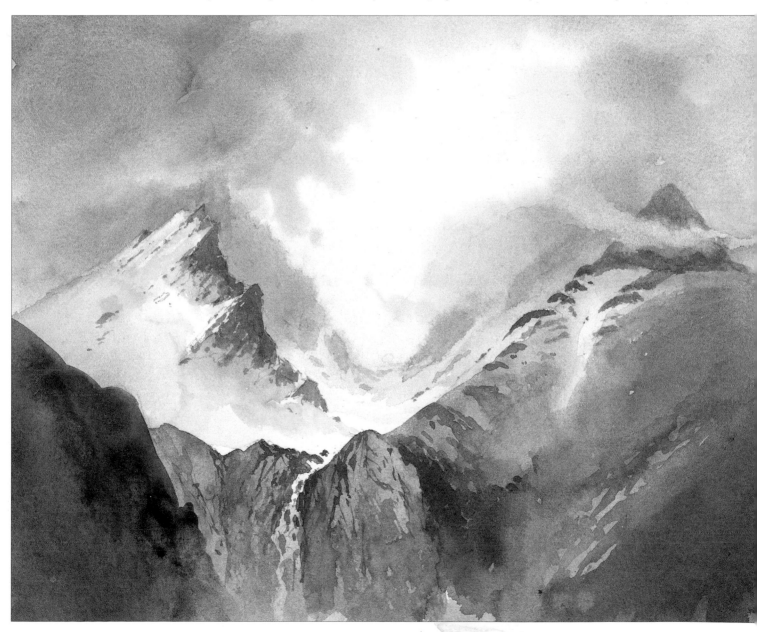

Materials

Paints

Watercolour paints are available in tubes, pans and half-pans. I normally use half-pans for outdoor sketching, and this is supplemented with tube colours on expedition or travel abroad. For the larger studio paintings, tube colours are essential as one can quickly mix large washes. Choice of colours is up to the individual, my own being fairly traditional with a sprinkling of modern pigments. I always work with artists' quality paints as they are more powerful and finely ground, but the students' variety are cheaper and there is not a great difference in quality with many colours. If you are new to painting, start with just a few colours and get to know them well before adding more. My basic colours are: French ultramarine, burnt umber, cadmium yellow pale, cadmium red, cobalt blue, Winsor blue or phthalo blue, alizarin crimson or quinacridone red, new gamboge, light red and yellow ochre.

Add the following colours when you feel confident, but preferably not all at once: burnt sienna, raw umber, aureolin, viridian, indigo, cerulean blue, Naples yellow, cadmium orange, raw sienna and vermilion.

To this list I would add white gouache, an opaque white with tremendous covering power. It is effective for those little splashes of white, for seagulls, white masts and many minor features you often need to highlight in a painting. All the paints mentioned above have excellent permanence. Study the manufacturers' labels and leaflets to avoid any fugitive colours. These will also tell you if the colour is transparent, opaque or falls between the two.

Paper

Watercolour paper can be obtained in imperial-sized sheets, or in various pads and blocks that are glued all round the four edges to avoid having to stretch the paper. Usually it comes in weights of 190gsm (90lb), 300gsm (140lb), 425gsm (200lb) or 640gsm (300lb), with some manufacturers having a more extended range. The 640gsm (300lb) paper is as heavy as cardboard, the 190gsm (90lb) version rather flimsy and prone to cockling. The 300gsm (140lb) paper will most likely need stretching before painting unless you work on really small sizes, so many people find the 425gsm (200lb) paper the ideal weight as it would not need stretching unless you are painting larger works, and it is less expensive than the heaviest type.

To stretch watercolour paper, I cut strips of gummed tape the length of the four edges, immerse the sheet of paper in water for a few seconds and then hold it up to dry for a moment until the paper is just damp. I then place the damp paper on my drawing board and stick it down with the wetted gummed strips. The board then needs to be laid flat and allowed to dry.

Papers generally come in three types of surface: Rough, Hot Pressed and Not (or Cold Pressed). You may find the smooth Hot Pressed paper a challenge to work on, as the washes dry quicker. It is excellent for fine detail, but you may find it best to leave this surface until you are more experienced. A Rough surface is extremely effective for creating textures, ragged edges, or with the dry brush technique to lay a broken wash, although it is not best for fine detail. The most popular paper is the Not surface which falls between the other two types in degree of smoothness. Try out paper from several manufacturers to work out which suits you best. Most of the paintings in this book are done on Saunders Waterford, with a few on Bockingford.

Brushes and pencils

Whilst the finest brushes for watercolour are undoubtedly sable, there are many excellent examples of brushes with synthetic filament on the market. Kolinsky sable brushes have a fine tip, a large belly to hold copious amounts of paint, and the ability to spring back into shape and not lie limp after one brush stroke. A good compromise if you find sables too expensive, is to buy a brush of mixed sable and synthetic hairs. Large squirrel-hair mops make lovely wash brushes, although they are prone to losing the odd hair now and then.

To start with a few brushes is quite adequate: a large squirrel mop for washes, a no. 7 or 8 round, a no. 4 round, a no. 1 rigger and a 13mm (½in) flat brush will suffice. Add a no. 10 or 12 round and a no. 6 round when you feel the need and you are well set up. More specialised brushes for certain applications, such as a fan brush, can also help on occasion, but are not essential. Take care of your brushes and they will last well. Wash them out with clean water after use.

You will also need a selection of pencils from 2B to 4B.

The brushes used in the step-by-step demonstrations in this book, from front to back: a no. 7, no. 4 and no. 1 round, a 13mm (½in) flat, a 6mm (¼in) flat, a no. 10 round and a no. 2 and no. 1 rigger, with a squirrel mop.

Wild night in town

I relied on the street lighting for this pencil sketch done in rain and wind. I had left my coat behind, but more importantly had a sketchbook on me. Never be without one – even a tiny square of card is better than nothing.

Other materials

Other items you will need include at least one drawing board, a putty eraser, a soft sponge, at least one large water pot, masking fluid and a craft knife. Also useful are bulldog clips, an old toothbrush for spatter, paper tissues and rags. I find a small water spray bottle is useful to speed up the accurate mixing of colours and occasionally for spraying over a damp wash to create a speckled effect. If you intend stretching paper then a roll of gummed tape will be required.

You will need a large palette on which you can lay out the colours you are using, many of which will be for small areas of detail, and some for slightly larger areas. A palette with deep wells is needed for mixing up pools of colour for the main washes. Many artists prefer to use a saucer, butchers' tray or large plate, and so long as it is white and does not affect the way you see the colours, these are perfectly fine. For a large wash, the whole saucer would be needed, but for small detail, many mixes can be made on one dinner plate.

For sketching outdoors, I sit on a foam pad and work with a sketchbook on my knee. It is best to travel light when sketching. I use a small box of half-pan watercolours, a few pencils and brushes and sketchbooks containing cartridge paper and watercolour paper. I use different sized sketchbooks in portrait format so that I can work over double pages when necessary. Also in my sketching kit are watercolour pencils and water soluble graphite pencils, as well as a plastic water pot. This is all stored in a belt bag.

Skies

Skies set the mood of a landscape painting and greatly influence the light, yet many artists barely give them any consideration. In this book you will find skies of all sorts, and they are not limited to this section. Time spent carefully considering how you will tackle the sky in a painting is never wasted, and in this section my aim is to show you a range of skies with the techniques used to create them, and also how to consider the composition of the sky and how it should relate to the landscape.

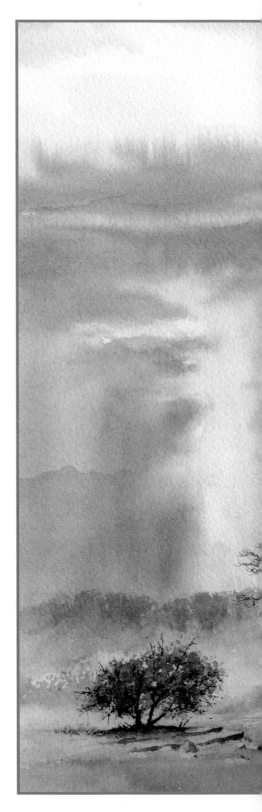

Occasionally I will come across a sky that fits in well with the scene I am sketching or painting, but most of the time I need to introduce a completely different type of sky to get the most out of the composition in terms of mood, lighting, logic and compositional considerations. This is where experience plus a wide selection of sky reference material is vital to success. The problem can be effectively solved in many ways, and there is rarely just one answer. So before starting a painting, I ask myself a number of questions: what sort of mood do I wish to create that would work with this composition? Do I want a cool, warm or neutral sky? What time of day do I want to suggest? Is there a need for the sky to be used to balance the composition? Can the clouds or light in the sky be arranged to highlight a prominent landscape feature? How should the sky relate to the landscape, especially where the two elements meet? Do I want intense light coming from some part of the sky and if so, where?

These questions may seem to introduce over-complication, but after a while they become second nature and most are instantly resolved. Once that has been done, you need to consider which colours to use, whether to work on wet or dry paper and the order of working. With just a little forethought and knowledge you can turn your skies into absolute gems, and as with so much to do with painting, it is often the simplest ones that have the most impact.

Taita Hills, Kenya

26 x 41cm (10¼ x 16⅛in)

The dramatic effect of cumulonimbus cloud formations provides a striking background to this African scene. I used vertical strokes with a large brush to create the downward effect, with plenty of water. Once this had dried, I worked more on the outer edges. The warm-coloured earth contrasts with the cool background.

Basic techniques for simple skies

Try out these methods on scrap paper before you start using them in a full painting. With watercolour, timing is often so critical, especially when you are working into wet paint as with the wet-in-wet technique shown opposite. The secret is to use as few brush strokes as you can get away with, and this will create a lovely freshness in your work. Naturally this means working with the largest brush you feel comfortable with for any particular passage. Limiting your brush strokes will also help you to avoid getting those embarrassingly green skies – often artists include yellow and blue in a sky and wonder why they get green. The answer is to apply them as separate colours and not blend them in with overbrushing, which will almost certainly guarantee a green sky.

In each of the following illustrations a generous pool of liquid colour was mixed in a deep well on the palette, and applied with broad strokes with a large brush, working horizontally across the paper and slightly overlapping each horizontal stroke to keep a uniform application of colour.

Lifting out

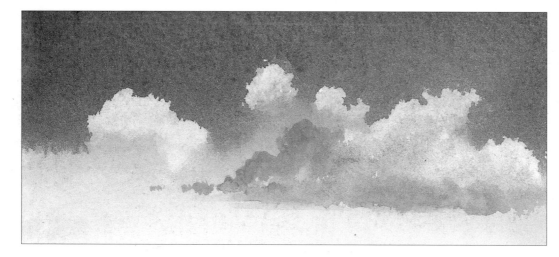

Immediately the dark wash was laid, a paper tissue was pressed into it for a few seconds. The paper was allowed to dry, then I washed over the lower part of the clouds with a light grey wash, softening it up into the white cloud with a damp brush. Finally, when it was dry, the darker clouds were introduced below.

Scrub-washed clouds

Using a round brush on its side, scrub it across the paper as shown to create rough and ragged edges to a cloud. This works well on a Not surface, but even better on a Rough one.

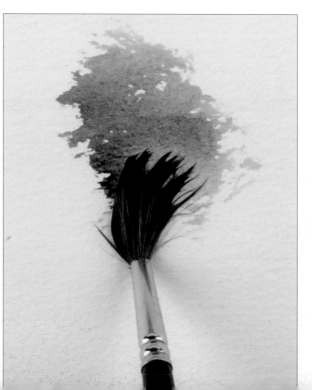

Dark wet in wet clouds

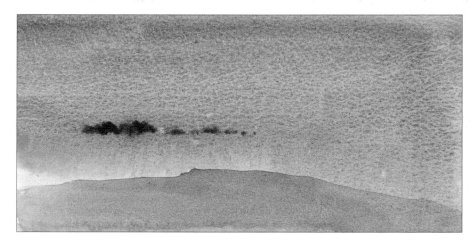

The dark line of clouds was added while the sky was still damp. For this it is vital that you have very little water on the brush, and a strong mix of colour, otherwise it will spread out and possibly create ugly cabbage-like runbacks. Timing is critical, so practise this on scrap paper first to gain experience.

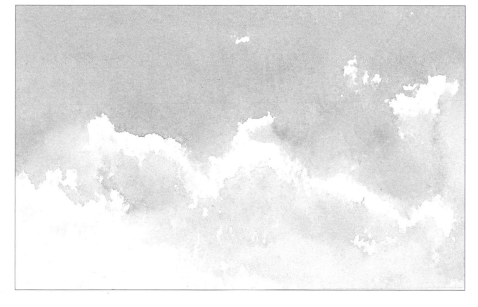

Negative clouds

The blue sky has simply been worked round the shapes of the white clouds on dry paper to create crisp edges. I added a slightly darker wash to the undersides of the clouds afterwards.

Cascading sky effect

This lovely effect is achieved by wetting the paper liberally and dropping a medium to dark coloured wash into the top part, to allow the effect to run down the paper. Try it while holding the paper at shallow and steep angles, and several points in between. Note that this effect can be laid on to a passage that you have already painted.

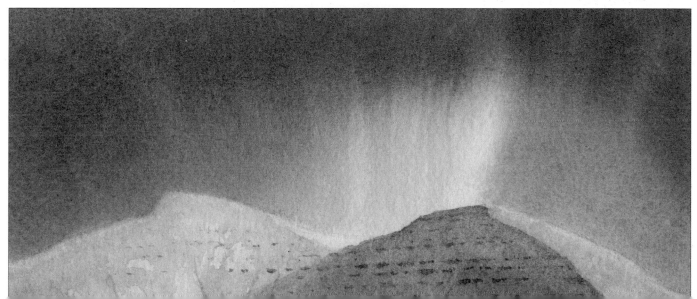

Two-stage sky

Many skies are painted with just one application of colour and allowed to dry, with nothing further being done to the sky area. However, with more complicated skies, and where you want dark, hard-edged clouds to appear in front of more distant ones, for example, you will need to lay washes in further stages. On this page you can see how a greater depth is suggested in the sky by painting it in two stages. The third illustration simply shows the land features completed.

1 I applied an initial wash of cerulean blue to the sky, working round the clouds, and then washed a weak application of permanent rose over most of the white areas. Lower down I dropped in a mix of cobalt blue and cadmium red while it was all wet.

2 When the paper was dry, I painted a mixture of French ultramarine and cadmium red to represent the darker left-hand cloud, softening the edge in places with a damp brush. Once this second stage of this type of sky is complete, the sky reveals considerably more depth.

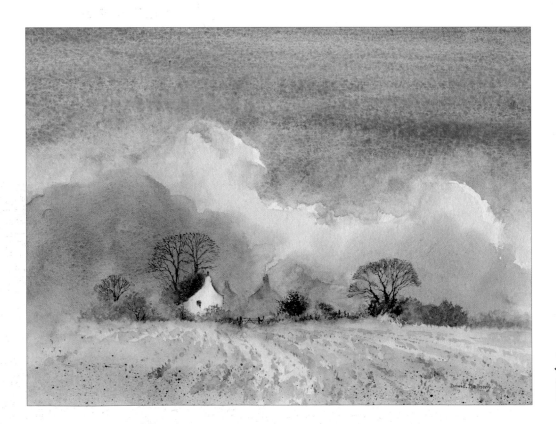

3 At this final stage the ground detail was painted in to complete the work.

Sky composition

Your skies will always benefit from some planning beforehand. In most landscapes the sky should enhance the land features without trying to dominate, and help to highlight the centre of interest, especially in those features that extend up into the sky, such as mountains, crags, castles, trees and so on. The positioning of elements such as large cloud masses, the brightest part of the sky, or the most colourful, can greatly affect the overall composition of the painting. On the other hand, you may wish to play down an area, most commonly the extremities of the painting, and in this case a glaze of transparent colour may be applied over that part of the scene you wish to subdue, as will be shown later in the book.

In certain cases you may wish to make the sky the focal point, and where you want to paint an extremely striking sky composition, it pays to make the land element take a subsidiary role, as in the case of the second painting below. I enjoy studying skies and occasionally a really powerful one will suggest a painting which is primarily a skyscape with just a minor role for the landscape below. It pays to carry out sky sketches whenever you can, and for this I often use watercolour pencils or the water soluble graphite ones.

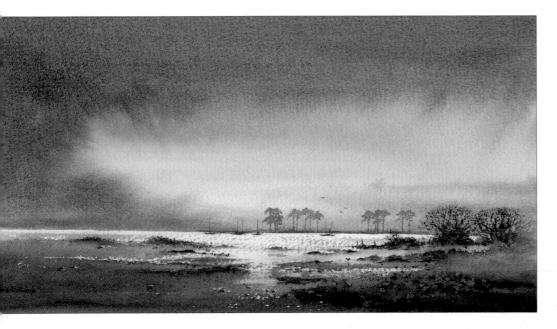

Beaulieu River Estuary
18 x 29cm (7¹/₈ x 11³/₈in)

Here the sky is composed to highlight the focal point, which is the distant trees and boats. These are emphasised by the brightest part of the sky – a simple, yet effective ruse.

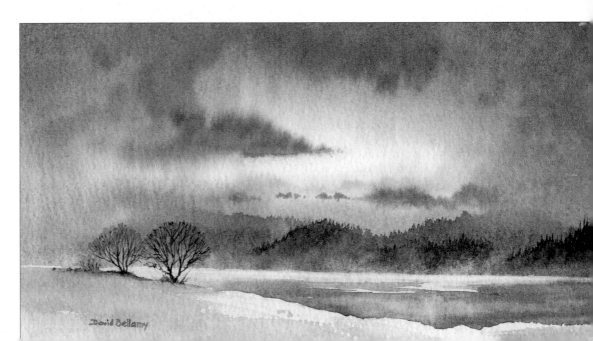

February Sunlight
12 x 21cm (4¾ x 8¼in)

In this watercolour the sky is so strongly rendered that it effectively becomes the centre of interest itself – and why not?

Types of cloud

With just a little thought and application, you can improve and vary your skies considerably. So many artists are content to simply apply a standard wash across their sky areas, and this can appear rather repetitive in an exhibition. Small or thin, streaky clouds can be used to break up large expanses of sky, wispy cirrus clouds can be bent to direct the eye towards a focal point, and dense stratus is useful where you want to throw the attention elsewhere on to a land feature. Cumulus clouds come in such a variety of shapes and sizes that they can be made to range from dark, threatening masses to light, airy white puffs scudding across a blue sky.

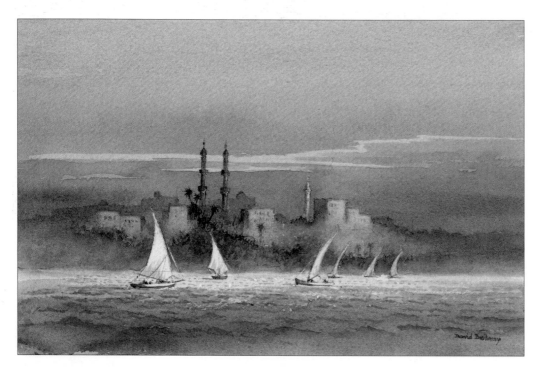

Approaching Dusk, Aswan
15 x 22cm (6 x 8¾in)

Fibratus – streaky clouds – can add interest to a sky, while at the same time intimating a restful serenity, as in this painting, so long as they are not overworked. This type of cloud is especially striking when viewed through tall trees, pinnacles or minarets, as in this scene in Aswan, Egypt.

Norfolk Creek
13 x 20cm (5⅛ x 7⅞in)

I like using cirrus, or wispy clouds, to highlight a focal point by pointing at it, rather in the manner of a stream or track leading into the composition. I often bend or zigzag these little gems to fit my scheme or mood.

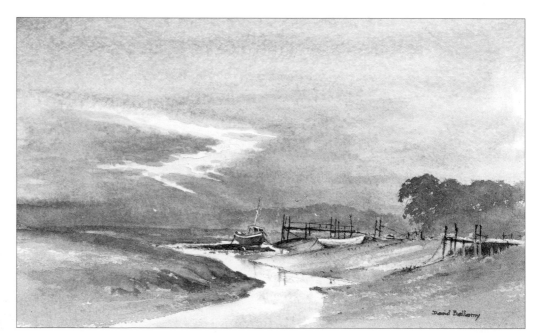

18

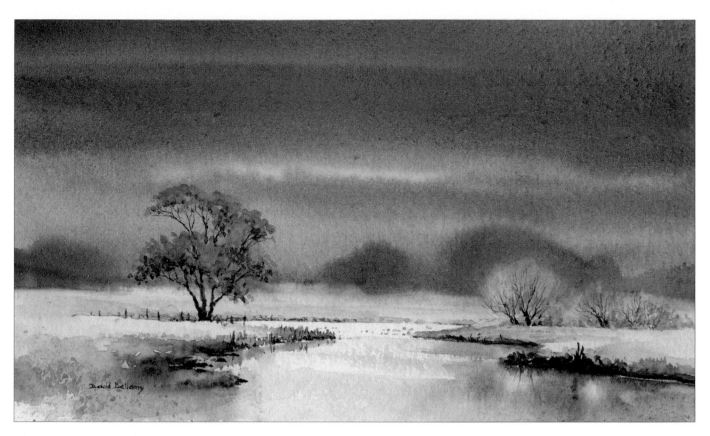

River Test, Hampshire

11 x 19cm (4³/₈ x 7½in)

Densely layered stratus can provide a supremely dull backdrop where you want to throw the emphasis elsewhere and increase the sense of light on certain ground features. It can also create the mood of an impending storm or something horrible about to happen.

Off Gateholm Island

12 x 24cm (4¾ x 9½in)

Cumulus can appear light and airy when set against a blue sky, or dark, angry and threatening in towering masses, and thus are excellent for setting the mood. Note the complete change of colour from the manganese blue hue above the clouds to the weak cadmium orange below.

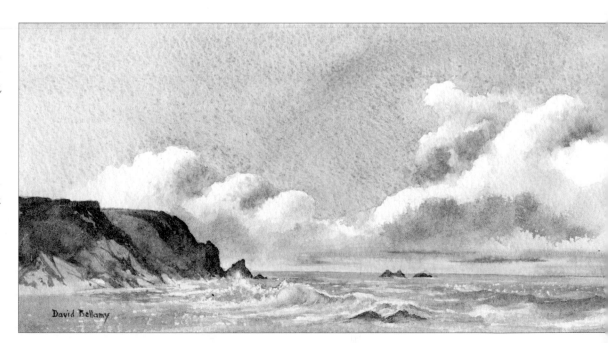

Silver linings

Creating silver linings can add sparkle to your skies, but it is best not to overdo the effect: a few simple ones tend to work better than a lining on every cloud. It also pays to break them up by making them intermittent rather than continuous for long stretches across the sky. Try not to make all your silver linings hard-edged. The occasional hard edge to a cloud can be effective, but including too many tends to spoil the overall effect.

Often the cloud structures are too complicated to include everything, as in this photograph where clouds were boiling up all around me. The energy and atmospheric power of the constantly shifting scene offered a challenge, but you have to identify the parts that excite you most – and render them quickly.

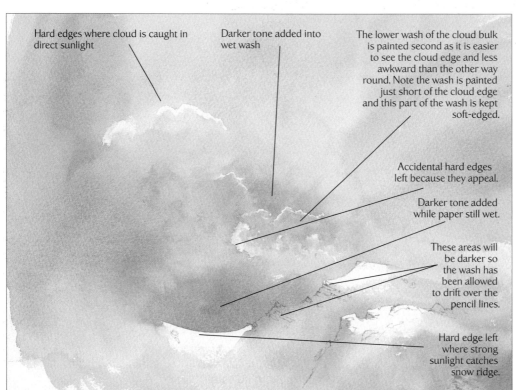

Hard edges where cloud is caught in direct sunlight

Darker tone added into wet wash

The lower wash of the cloud bulk is painted second as it is easier to see the cloud edge and less awkward than the other way round. Note the wash is painted just short of the cloud edge and this part of the wash is kept soft-edged.

Accidental hard edges left because they appeal.

Darker tone added while paper still wet.

These areas will be darker so the wash has been allowed to drift over the pencil lines.

Hard edge left where strong sunlight catches snow ridge.

1 In the interest of keeping things simple I have subdued the urge to put too much energy into this watercolour, as I want to illustrate how the silver linings are achieved. Firstly the upper part of the sky is painted with a wash of weak cobalt blue plus cadmium red on dry paper, working round the tops of the cloud edges, and running the wash under them for a short distance. The edge of the wash under the linings is softened off with a damp brush. While this is all wet, Naples yellow is drifted into the area between the cloud masses, then cobalt blue and perylene red to give the clouds a sharp, defined edge.

2 When the paper is completely dry, clean water is brushed over the areas under the tops of the clouds, over the end of the previous wash, taking it out into the sky beyond the silver-edged clouds. Next, a darker grey, made up of French ultramarine and perylene red, is applied carefully – I prefer to use a no. 10 or 12 round sable for this, as the fine point helps to retain a thin rim of white at the tops of the clouds. This wash runs into the wetted areas and thus creates a soft transition below the silver linings, but the cloud limit is indicated by the soft-edged darker mass. Then the mountain ridge is added.

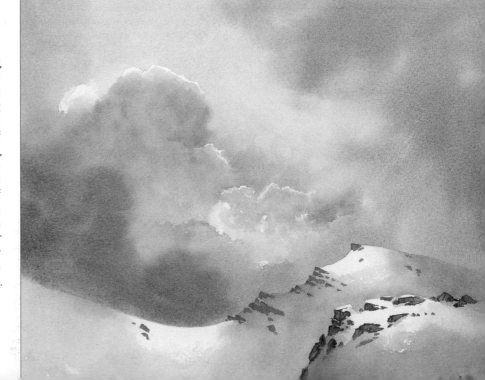

Sunsets and fiery skies

Sunsets can make exciting paintings but can appear garish if too many bright reds and yellows are included. Like most things in painting, they usually need to be simplified. Often they are best painted in two or three stages, normally allowing each stage to dry before going on to the next. You need to fix clearly in your mind the exact point where the sun will be, whether you are including it or not. This helps you to determine if any silver lining will appear at the top or the bottom of a cloud, for example, or when rays of sunshine are emanating from a particular point. Note that distant objects on or near the horizon are usually starting to get lost in strong atmosphere, while closer objects may stand out strongly as silhouettes. In very strong atmospheric conditions, the horizon may disappear completely and sky will gradually merge into land. With so much colour in the sky, you will need to play down any strong colours in the land element.

One of the dangers of working from photographs of sunsets is that all the non-sky features may simply appear as black silhouettes, whereas when you are on the spot, you can usually see some colour, form and detail in those features, if only vaguely. In painting your scene with stark photograph-like black silhouettes, you will be losing that subtle effect and creating a cut-out image of the scene that lacks a natural response.

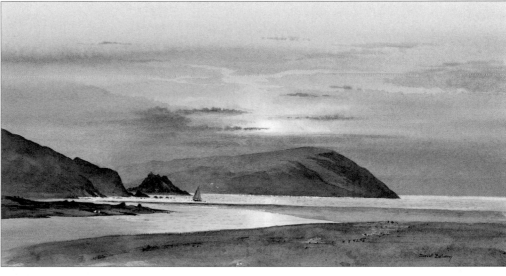

Sunset, Newport Bay
18 x 32cm (7¹/₈ x 12⁵/₈in)

Sunsets are often so complicated that they need considerable simplification. This sky was done in two stages. Firstly I laid a weakish wash of permanent alizarin crimson in the upper sky, running it down into the centre where I laid in some Naples yellow. While this was still wet, I worked in some new gamboge, blending it into the Naples yellow and describing the shape of the sun. When the paper had dried, I applied a stronger wash of permanent alizarin crimson with a touch of French ultramarine into the upper part of the sky, leaving streaks of untouched paper to reveal the earlier lighter wash of alizarin. Lower down I introduced much more ultramarine into the mix, taking it down over the headland, and while the paper remained wet, I added strings of horizontal clouds with an even stronger mix of the same colours. For the headland, I included permanent alizarin crimson in the mix to retain a sense of unity.

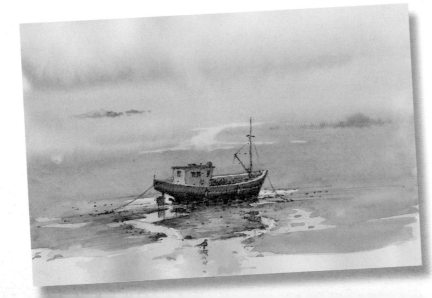

Boat at Tenby – wash and line sketch on cartridge paper

On moody evenings the horizon is often obscured in the misty atmosphere, and here I ran the colour of the sky into the sand. This throws great emphasis on to the focal point. The dark clouds were added wet in wet, while the streaky one was taken out with a thin flat 13mm (½in) brush.

21

Shafts of sunlight

A powerful tool for highlighting a centre of interest is a shaft of sunlight, and it is also useful for breaking up less interesting passages and creating variety. These effects can be achieved in a number of ways, and occasionally I find it necessary to employ two quite different techniques on the same lighting effect.

Firstly the stopping-out method, as shown in the upper illustration, involves laying a dark or medium-dark wash across the area where the shafts of light will appear, and then immediately lifting out the shafts with a tissue or large damp brush. To create an authentic-looking light shaft, it is best to repeat the lifting out process down the centre of the shaft of light so that the beam seems to be more intense there. The second method employs a stencil technique and this is done after the dark or medium-dark wash has dried, as in the case of the lower illustration. Take two strips of thin card or watercolour paper and lay them along the lines where the shaft of light will appear, one on either side, revealing where the centre of the shaft will be created. Draw a soft sponge and clean water down between the two strips of card as many times as are needed to create the shaft, then dab with a tissue to remove excess water. Reposition the card strips at the same angle but slightly further out from the centre-line of the shaft, and sponge again gently. The idea is to create soft edges to the shafts, so one gentle stroke might be sufficient to achieve this, otherwise continue until the required result is achieved.

Thirdly, the shafts can be created by painting them with white gouache. This is best done on a rough surface to create the right effect, and is an excellent method when painting on tinted paper. A fourth method, of working negatively with a dark wash down each side of the sunlight shafts, can also produce the effect desired, but I generally prefer the other techniques. Be aware that when you wish to include several shafts of light, they should all start from the same point in the sky, whether you include the sun or not.

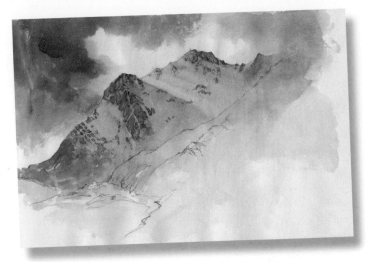

Shafts of Sunlight Across Aonach Beag, Scotland

In this watercolour sketch on cartridge paper my main objective was to record the effects of how the slanting shafts of sunshine created light and shadow areas across the face of the mountain, together with the cloud formation that was causing this phenomenon. Speed was essential, as this sort of effect does not last long, and also it was spitting with rain. I actually painted the whole face in the shadow colour, then immediately pulled out the lighter shafts with a damp no. 10 brush. As I wanted to preserve my efforts, I stopped sketching once the rain became heavier.

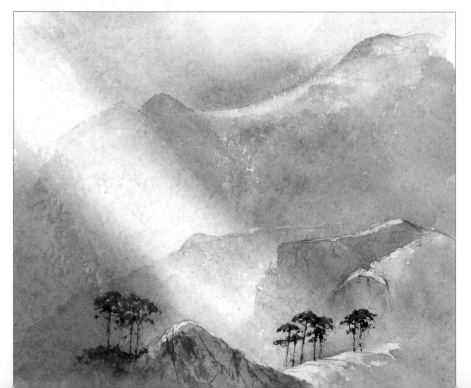

Sunbeams in the Ogwen Valley
15 x 18cm (6 x 7¹/₈in)

In this small watercolour of a valley in Snowdonia, Wales, the background mountains were painted first and allowed to dry. Then a soft, natural sponge was rubbed diagonally over the area where the shaft appears, shielding each side of the shaft initially with thin card, then softening the edges caused by the card. Doing these procedures in this order enabled me to achieve a soft transition at the edges of the shaft of sunlight. Once all this was dry, I added details of the trees and closer crags.

Graduated skies

Graduating your sky washes is a simple and effective way of adding interest and variety to both the main part of the sky and to small passages between clouds. This is such a common phenomenon in skies that the technique should be in every artist's repertoire. Note how in the illustration below the sky is really dark at the top and much lighter where it meets the distant hill. Had I left it as dark throughout, the hill would be lost in the dark mass. Also, the graduation method has been used on the crag to throw the emphasis on to the part nearest the centre of the composition.

Graduation is vital if you include the sun in your sky as it can suggest the intensity of light close to the sun, gradually revealing the sky to become darker, however slightly, as the distance increases. In the vertical plane, especially with almost clear, blue skies you will see the tone graduate from a darker blue at the top to a much lighter one at the horizon, although this can depend on the position of the sun. The trick is to observe these effects when you are out and about, as you can learn so much even without a sketchbook.

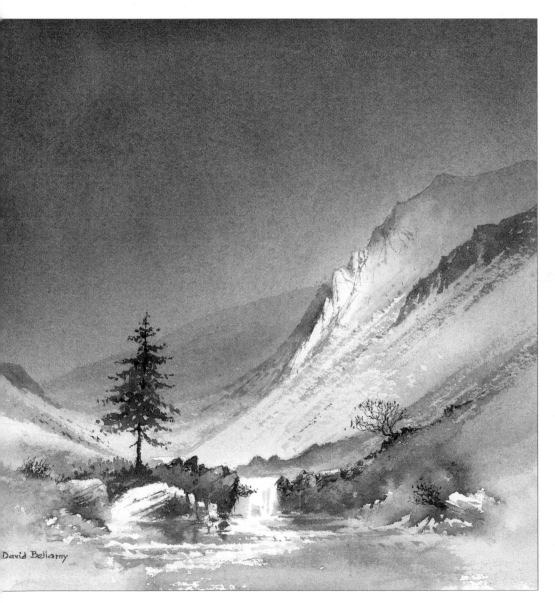

David Bellamy

Irfon Valley
19 x 19cm (7½ x 7½in)

In this Welsh scene, I wanted to create a simple, graduated sky to throw the attention on to the crag and cascade, at the same time suggesting a brooding atmosphere. The distant hill was painted first using indigo with a touch of burnt umber. When this had dried, I completely wet the sky, the dark top of the crag on the right, and the hill I had just painted. A strong mixture of indigo with some burnt umber was then washed down the sky. I made it extremely dark at the top, adding a little more water to the wash lower down, and much more water near the bottom of the sky. I worked hard to keep the light part of the crag from being over-run, and it needed a lot of mopping up at the bottom where I ran in some cadmium yellow pale. Washes flow beautifully if you wet the paper first, but of course, if you need hard edges in clouds, this method will not work.

Creating a sky to complement a landscape

When you consider what type of sky you wish to include with a particular scene, think of the effect as a whole and not just the two main elements in isolation. The light and atmosphere will affect both sky and landscape equally, and where you position clouds and the light source may have a profound effect on a landscape feature. As with the land elements, it often pays to do little thumbnail sketches to ascertain the optimum position for the main clouds and light, and make sure you do this in conjunction with the ground features. If there is a strong mist, take care not to have any hard edges on distant objects, as this will jar with the overall impression. Puddles will suggest a rainy or showery day, so it helps to include a few clouds that also suggest this. Strong directional clouds, as in the photograph opposite, can be used to point towards a landscape feature.

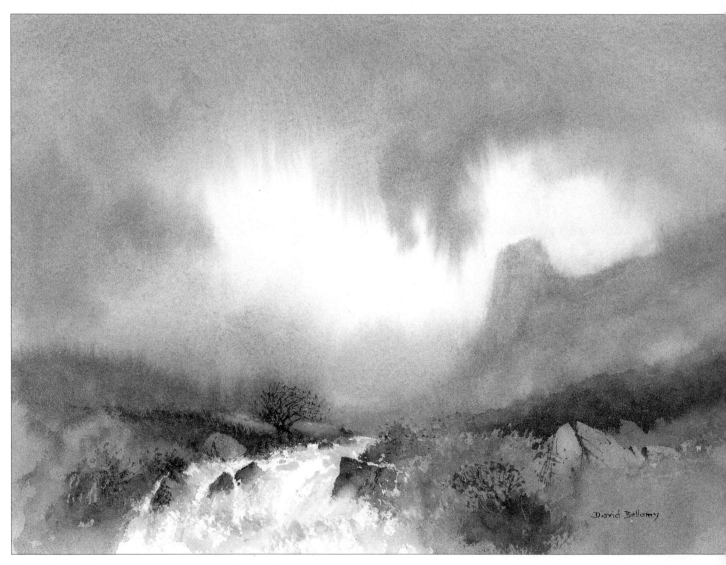

Lowering Sky
17 x 24cm (6¾ x 9½in)

A device I commonly use with skies is to create a swirl of cloud around a prominent ground feature, such as a castle on a hill, a shapely mountain summit or, as in this case, a crag thrusting out from a ridge. I have not included any detail on the crag because it is not the focal point. Giving the sky a more interesting composition that complements part of your landscape will add more power to your painting.

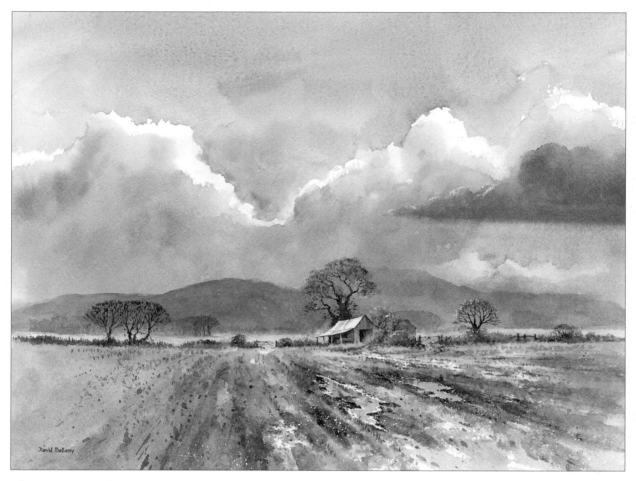

Showery Morning
28 x 37cm (11 x 14⅝in)

Varied and fairly heavy clouds imply a showery day, and in this watercolour my aim was to give the impression that the rain had just stopped and the sun had come out. The effect I have tried to achieve is that of high backlighting from the late-morning sun which causes a sparkling effect on the rims of puddles and beads of moisture on the ground. Painting in a light to medium wash of French ultramarine and cadmium red over the puddles, I stopped just short of the edges to leave a white rim, and then dropped in a few touches of reflections while the wash remained wet. The dark, muddy outer edges emphasise the white rim further. For the sparkling beads I spattered white gouache over the ground area.

Beefing up a sky that lacks impact

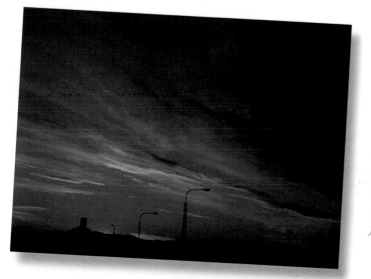

Evening Sky

This photograph shows a sky that has a strong directional pull, and this effect can be useful for highlighting a feature such as a castle or mountain peak, which could be positioned at the lower end of the cloud formation, in this case the

DRAMATIC SKY

While many skies can be rendered with just a single wash, I shall now demonstrate a more complicated sky where more than one application is necessary. You will also see how important it is to re-adjust certain washes while they are still wet, by using a damp brush to pull out straggles of paint that have strayed too far.

Materials used

Saunders Waterford 640gsm (300lb) Rough watercolour paper

Brushes: squirrel mop, no. 10 round, 6mm (¼in) flat, no. 7 round, no. 1 rigger

Colours: Naples yellow, cadmium orange, cerulean blue, indigo, cadmium red, yellow ochre, cadmium yellow pale

Masking fluid and old brush

Paper tissue

Craft knife

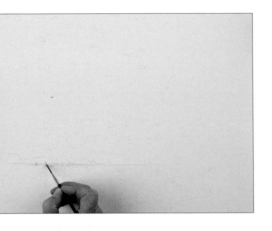

1 Draw the scene. Use an old, fine brush to apply masking fluid to the water's edge and the two yachts. Add a few tiny dots lower down to suggest sparkles in the water.

2 Wet the sky, and use the squirrel mop to drop in Naples yellow in the centre and at the bottom. Drift cadmium orange into the left-hand side, then cerulean blue at the top, working round untouched paper to suggest clouds. Wetting the paper first gives soft edges. Allow to dry.

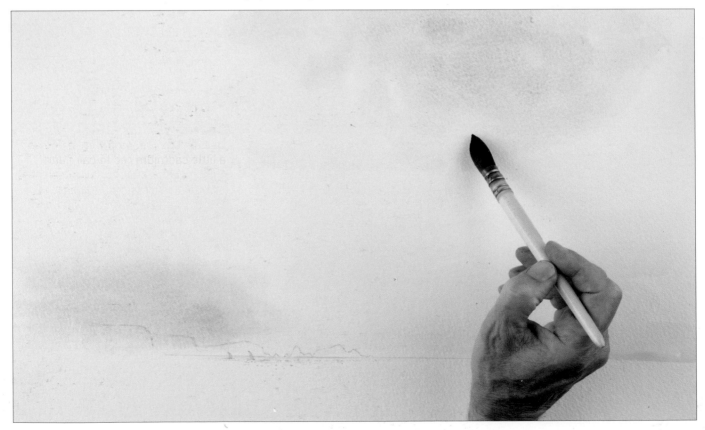

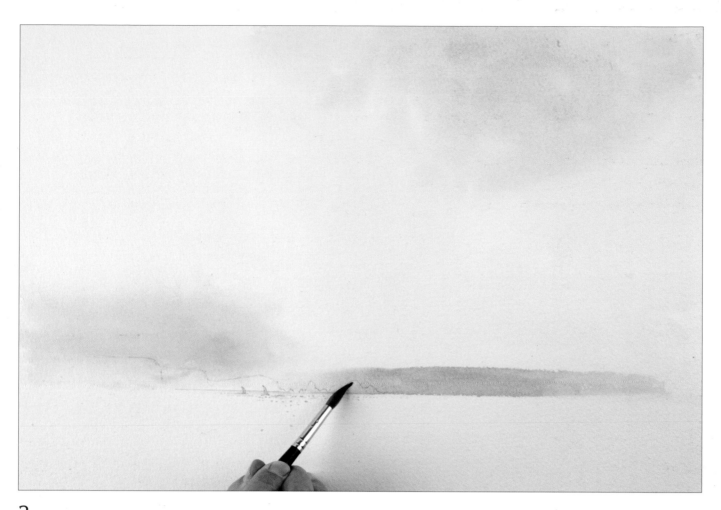

3 Use the no. 10 round brush to paint the distant mainland with a pale grey mix of indigo and cadmium red. Fade either edge and soften the top a little with a damp brush. Allow to dry.

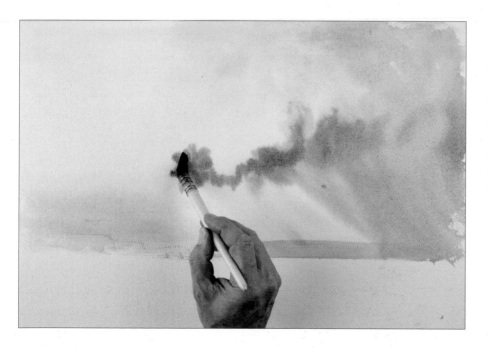

4 Wet the whole sky area again. Use the squirrel mop with indigo and a little cadmium red to paint dark clouds running into the cerulean blue area. Make the clouds stronger in places and paint shafts of light and dark down to the sea. The shafts of sunlight should all begin from the same (unseen) point, but as they spread out, they will be at slightly different angles.

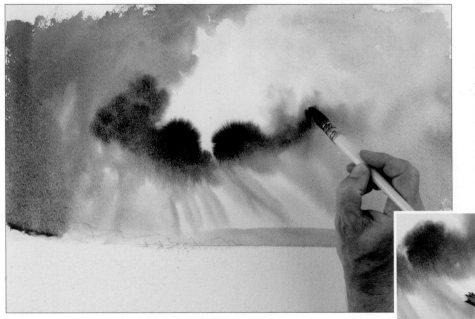

5 Continue painting cloud shapes and shafts of light and dark. Paint very dark clouds in the centre with indigo and neat cadmium red. Use the 6mm (¼inch) flat brush to pull out colour and correct any hard lines that appear as the sky develops. This is especially important with the shafts of sunlight (see inset).

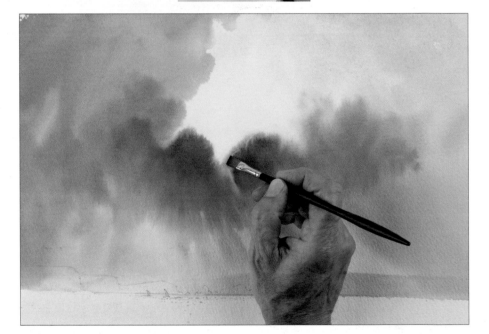

6 Lift out some colour at the edges of the central very dark clouds with the 6mm (¼in) flat brush, to show where light is catching the cloud edges. Allow the painting to dry.

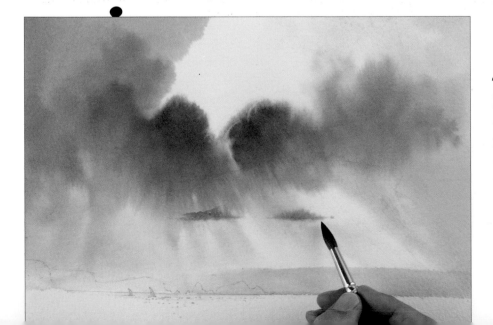

7 To introduce a couple of smaller clouds in front of the shafts of sunlight, re-wet the central area of sky carefully, brushing the water in the direction of the light shafts. Take the no. 10 brush and a mix of indigo and cadmium red, then drop in small lateral clouds below the darkest clouds. Blot out the bottoms of the clouds with paper tissue.

8 Put a little more cadmium red in the mix and paint in the headland and islands with the no. 10 brush. Tidy the waterline with a damp 6mm (¼in) brush.

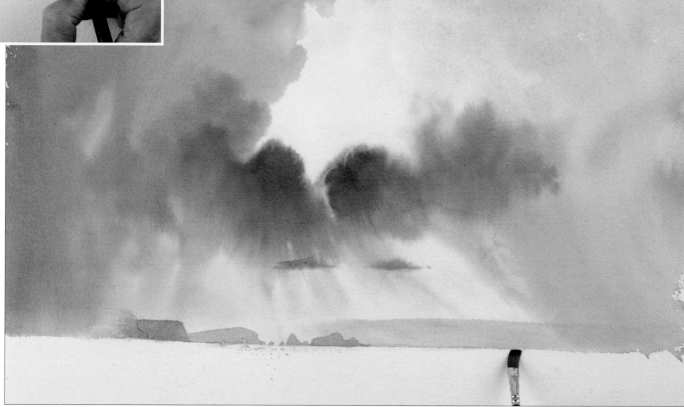

9 Strengthen the nearest part of the headland to bring it forwards, with indigo and cadmium red, then drop in some touches of yellow ochre. Allow to dry.

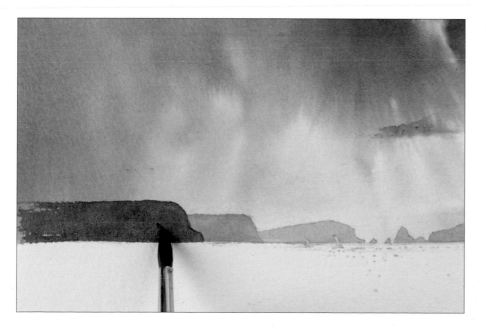

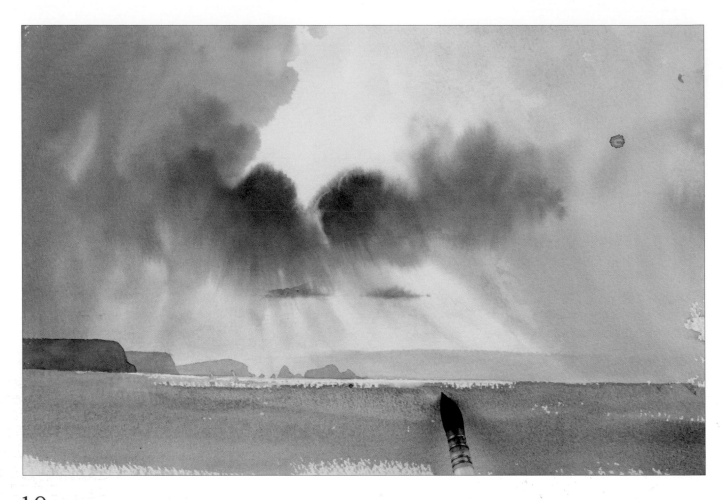

10 Paint the sea using the squirrel mop and a mix of indigo and cadmium red. Sweep the colour across the paper, leaving tiny white bits to suggest sparkles. While this is wet, sweep in cadmium yellow pale below the shafts of sunlight. Allow to dry.

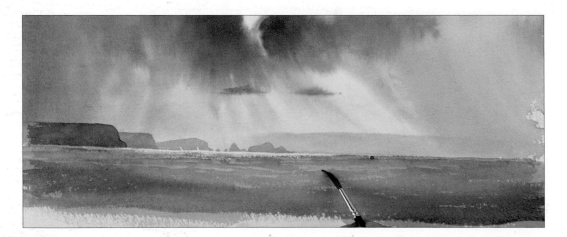

11 Remove the masking fluid and go over any excess white with indigo and cadmium red on the no. 7 brush. Hint at waves and darken the bottom of the painting with the same mix.

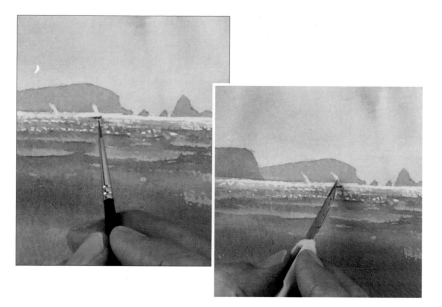

12 Use the no. 1 rigger to paint one yacht hull in cadmium red, then use a craft knife blade to tidy up the sails and to scratch out ripples in the sea.

The finished painting.

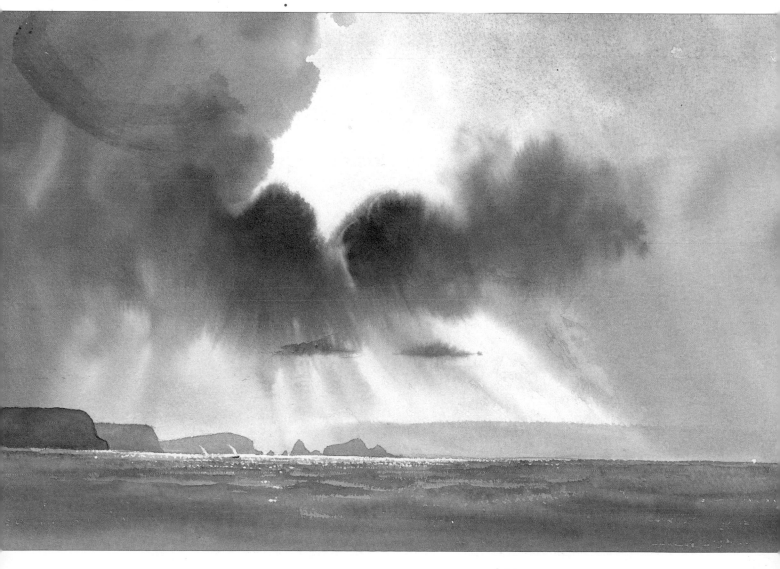

Light

Light is a fundamental requirement for our painting, and with consideration it can be one of the most exciting aspects of our work, especially when combined with strong atmosphere. In this section we look at how we see direct light, the riveting power of cast shadows to suggest sunshine, the magic of reflected light, shimmering light, the colour of light and how atmospheric conditions can affect the way we see lighting. Here, the intention is to add something special to your paintings, to lift them above the average, often with little devices that are quite simple to inject into your work.

So often we see dull, lifeless watercolours where the lighting is so flat and boring that however well we have executed the work, it does not stand out from the crowd. With a little thought and know-how, you will find your paintings given a tremendous lift by the techniques shown in the following pages. One word of warning, though – don't try to include them all in one painting! Resist the urge to overwhelm the viewer with stunning light effects all over the composition. If everything sparkles, then nothing will stand out as a strong focal point.

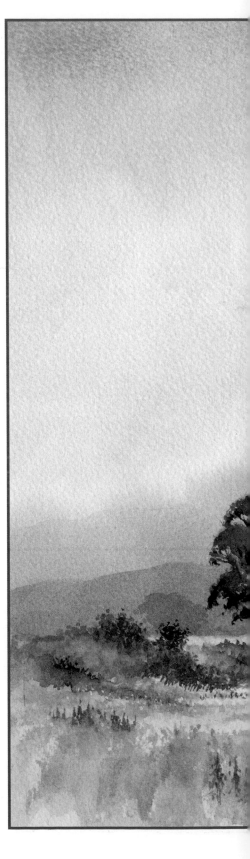

Shropshire Hay Field
24 x 35cm (9½ x 13¾in)

There is nothing like cast shadows to suggest sunlight. In this watercolour they are beginning to lengthen as late afternoon turns into early evening.

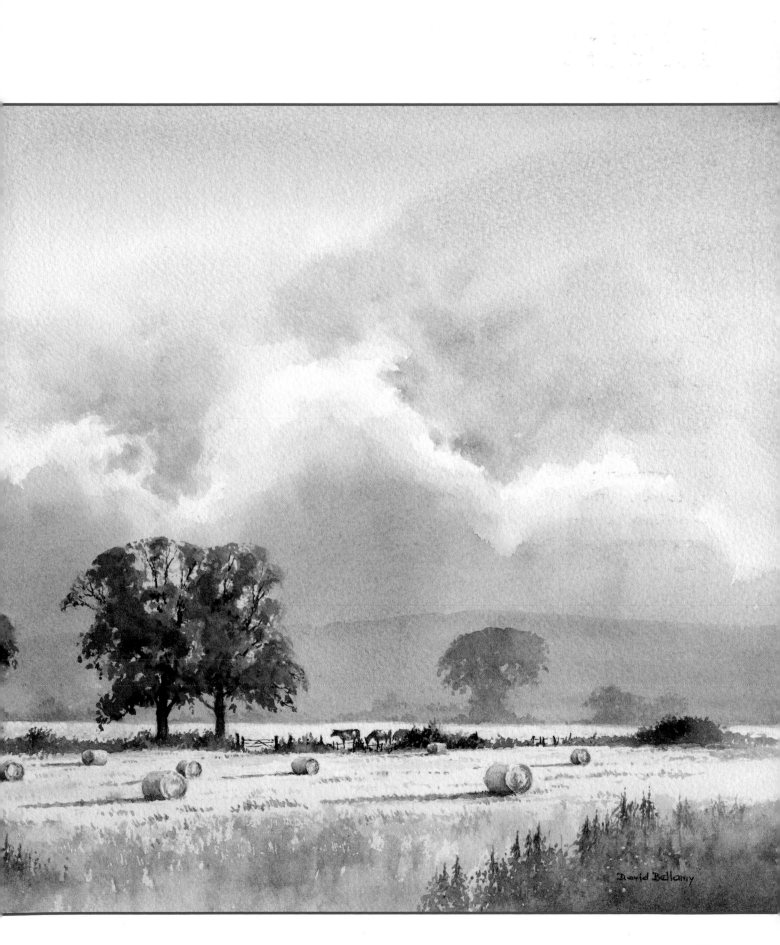

Warm and cool light

Colour temperature can be an effective tool in suggesting the time of day, as well as giving an impression of hot or cold weather, and this can affect the whole painting, or just a part. Even with a snowscape you may wish to put across a sense of warm evening light catching snowy features, so a glaze of permanent alizarin crimson over those features might work well. If you want a certain passage in the painting to appear warmer, then paint cool blues, greys or greens next to it and this will intensify the warm colours. Note that some reds, for example, are warmer or cooler than other reds, and so on. Here we look at how to suggest early morning and late evening by the quality of light.

Barn at Trerickett
20 x 29cm (8 x 11³/₈in)

The cool light and long shadows suggest very early morning, as the day has not yet warmed up.

Sugar Loaf Mountain in Fading Light
18 x 22cm (7¹/₈ x 8⁵/₈in)

The warm light reflecting on limestone crags gives a strong sense of approaching dusk in this Welsh scene. Creating half-lit features in a painting makes the viewer feel that the sun is sinking low.

Laying glazes to increase light effects

A transparent glaze washed across a part of the painting that has thoroughly dried can be an impressive method of subduing that passage or highlighting an adjacent one, as well as warming or cooling an area. In both the illustrations on this page, the glazes have had the additional effect of suggesting distance.

Aqaba Pass, Gilf Kebir, Egypt

Capturing a sense of intense heat in this watercolour sketch in an A4 book was achieved not only by strong contrasts on the foreground rocks, but also by laying a glaze of weak cobalt blue over the background, including the sky. Initially all the background mountain had been painted with the same warm Naples yellow you see in the foreground. There was no wait for the wash to dry as this is one of the hottest places on earth.

Weak detail applied, then when this had dried, a weak glaze was washed over the whole background.

As this is closer to the foreground, the detail has been made stronger so that it shows up better under the glaze.

The glaze avoids the pinnacle so that it stands out well.

Pinnacle, Bullslaughter Bay, Wales
28 x 21cm (11 x 8¼in)

The rock pinnacle has been made to stand out by the lack of detail or hard edges in the background cliff. This was achieved by painting in some weak detail, allowing it to dry and then laying a transparent glaze of French ultramarine with a touch of burnt umber right across the background, thus subduing further the suggested detail.

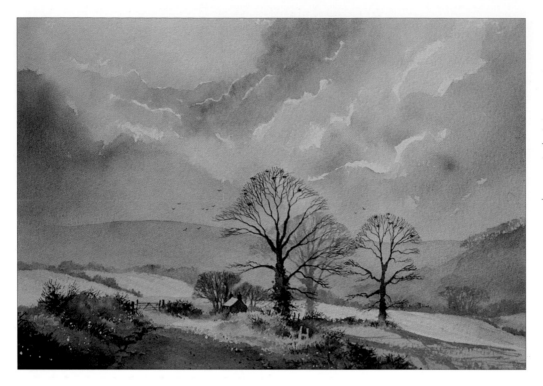

Country Lane
20 x 28cm (7⁷⁄₈ x 11in)

The lighter parts of the scene such as the cottage roof and the further part of the lane have been accentuated by leaving those areas as white paper, and the middle-distance fields are off-white. This provides strong contrasts with the closer fields, trees and hedgerows, suggesting a sunny feeling in the middle distance.

Introducing manufactured light to intensify contrast

Many scenes can benefit from altering the strength of tonal contrast to make certain features stand out. Creating a stronger light area by improving or manufacturing a light patch is an excellent technique to highlight a focal point, and both paintings on this page have been improved in this way. Sometimes it simply involves leaving the paper untouched, as with the cottage roof in the upper illustration, and creating strong darks next to that part. Consider your original source material carefully before working on the really critical aspects of the scene, whether you are working from sketches, photographs or out in front of the actual scene. Does it need emphasis or increased contrast? Maybe try a thumbnail or two of that particular spot in the composition. Don't take every scene and paint it exactly as it stands. The light is constantly changing and thus the relationship between all the various features also constantly changes, so this is a superb way in which to exercise your creativity.

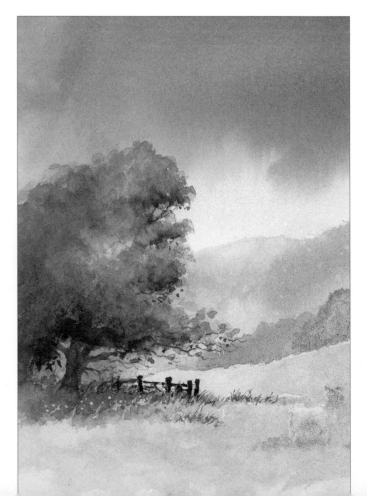

Summer Tree

In this small part of a watercolour painting the background field has been painted with a lovely bright yellow, even though the actual field was a drab green. The yellow lifts the scene, making the fence posts stand out, so don't be afraid to spice up parts of your composition with some manufactured light in this way.

Using cast shadows to avoid repetition

You will come across many examples of repetitive detail in landscapes, and however exciting each bit of detail may be, the overall effect can appear rather uninteresting if all is included. An excellent way to reduce this repetitive boredom is to wash cast shadows over part of the scene, whether it is a long line of intricate cliff structure, a forest in the middle distance, a mass of buildings, as in the example below, or one of many other instances of elaborate detail.

Pick out the most exciting features that you wish to highlight and work a wash round them, creating both hard and soft edges to the shadow wash if possible. Either make one part stand out strongly by including extra detail, or make some foreground feature stand out in powerful contrast to the background mass.

Amman

I gazed across the rooftops in Amman, Jordan, and saw the whole scene was lit up by strong morning sunshine, every building brilliantly lit. This would make for a rather boring painting, so after drawing the main buildings in, I laid a shadow wash over all but those I wished to stand out, then added some darker shapes in places. The palm trees and minarets were especially useful in creating variety and depth. This technique is excellent for reducing repetition.

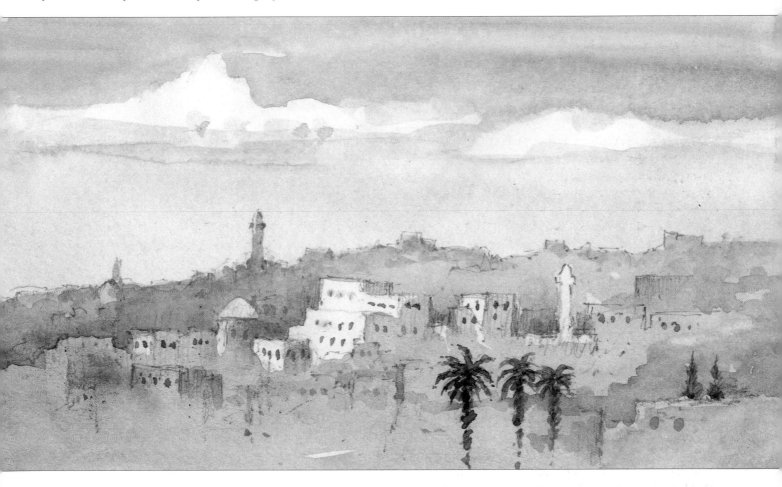

Light from various directions

The four images on these pages show the light source coming from different directions, and how this can affect the overall impression. I often change the direction of the light from that shown in the original scene, sometimes quite dramatically, to suit the mood I wish to create. The stone barn illustration at the bottom of this page has been kept deliberately dull to highlight the problem, when in fact I would normally spice it up quite a bit.

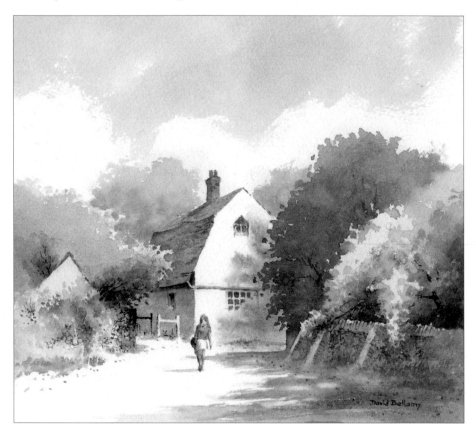

Cambridgeshire Village – Side Lit
20 x 20cm (7$^7/_8$ x 7$^7/_8$in)

Lighting coming from one side can emphasise form and is extremely useful when depicting cast shadows.

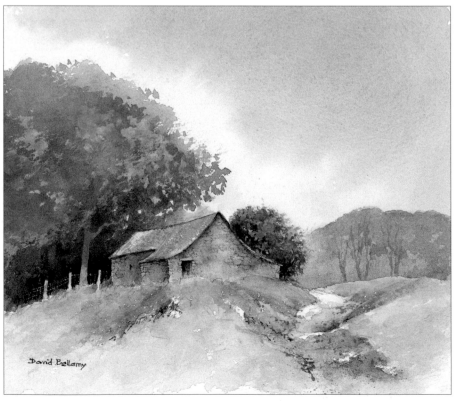

Stone Barn – Front Lit
15 x 18cm (6 x 7$^1/_8$in)

The light here is not strong but the extreme ends of the barn stood out, as they were against really dark features. However, I had to emphasise the darker left-hand side of the barn as the front lighting simply made the structure look too flat. This can be a problem when sunlight catches the two sides you are viewing, so one should be exaggerated, as in this case.

Summer Lane – Top Lit
16 x 13cm (6¼ x 15⅛in)

Around the middle of the day during the warmer months, sunlight is angled from high above the subject. This can create strong highlights on the tops of trees, buildings, vehicles, and so on. Cast shadows are correspondingly minimised as shown in this scene. High back lit scenes can appear really dramatic.

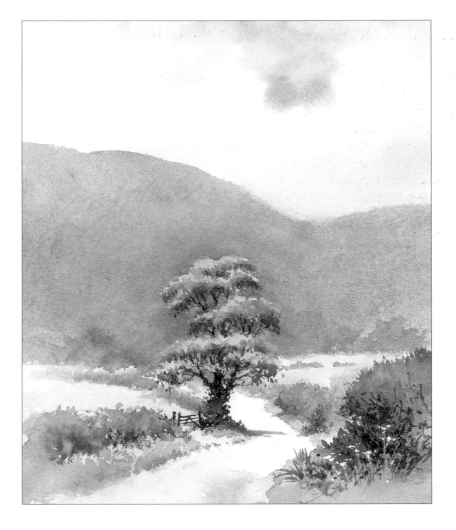

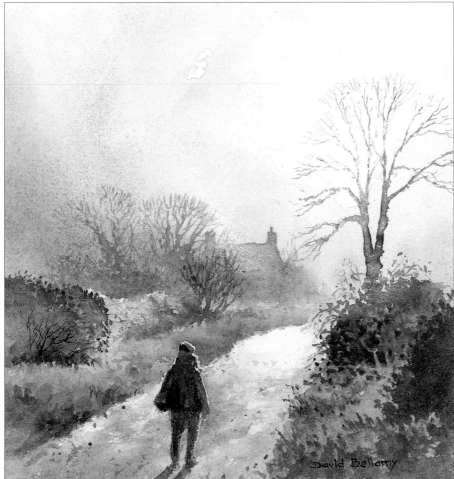

Lane at Evening – Back Lit
13 x 12cm 5⅛ x 4¾in)

Back-lit views can increase the drama and atmosphere considerably, and can simplify the more distant features, often to the degree that they appear only as silhouettes. Many objects, especially the closer ones, can have light rims around them, as on the figure in this scene.

David Bellamy

Intense sunlight

Capturing the sensation of intense sunlight is not too difficult, and as with so much to do with painting, creating a really authentic response relies on careful direct observation. In the first picture we study direct sunlight and how it appears to burn out any feature close to the line of the sun, and at the same time imparts a powerful orangey-red glow to the closest features such as branches. More often, however, you will be concerned with how strong sunlight falls on an object or landscape feature, as portrayed in the other two illustrations. Strong contrast between lit and shadow areas is, of course, vital, but also watch out for that shimmering effect you sometimes see where shafts of sunlight fall on parts of the scene: you can see this effect in the painting opposite, just above the building and slightly to its right. Here the edges have been softened and the contrast between light and shadow is less intense.

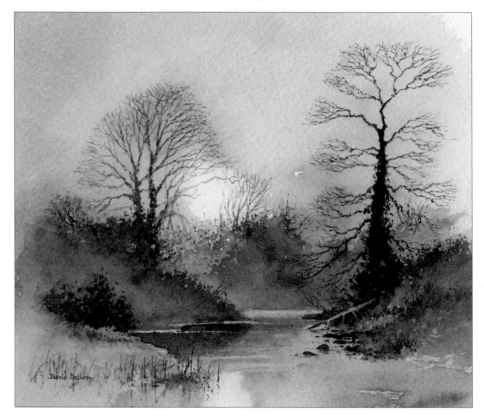

Setting Sun
15 x 17cm (5⅞ x 6¾in)

The power of the setting sun as you look at it can bleach out detail in features such as tree branches. Take care looking directly into the sun – unless it is very weak, use dark glasses, preferably the grey-tinted variety rather than those with a colour cast. Many of the elements become silhouettes, often with a warm colour cast closer to the sunlit area.

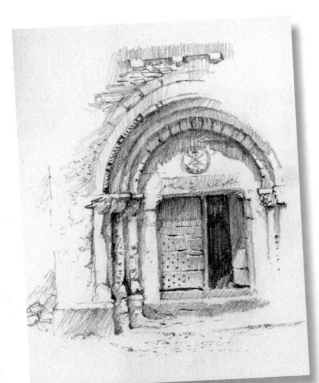

Doorway of Eglise Saint-Éxupère, Arreau

In this pencil sketch I tried to put across the sense of intensely strong sunlight falling on the ancient doorway and heightening the worn nature of the stonework. However, avoid putting too much detail into an area that is catching strong sunlight, as it will detract from the effect.

40

Beneath Mount Sinai
31.6 x 45.7cm (12½ x 18in)

The intense midday sunlight falling on rocks has been accentuated by leaving the tops of the rocks as white paper to provide strong contrasts. The sun is slightly to the left in this painting, and the scene is back lit. Note the reflected light illuminating the white-washed front of the building and on the right-hand side of the rock just to its left. A heat-haze obscures much of the cliff detail in the rear.

Painting the sun

Sometimes it can be really effective to include the sun in your painting. It needs careful placement, and is most usually included in scenes depicting very early morning or towards sunset. Avoid placing it slap in the centre of your sky, and to increase its effectiveness you might wish to position it directly over a stretch of water to create a reflection highlight. You may also want to obscure it slightly between tree trunks, behind bare branches, or with atmosphere or part of a cloud. Sometimes a stark circle can appear too intrusive and partly obscuring it in this way can improve the effect. I also lay a thin transparent glaze across it on occasion, to suggest the sun shining through a thin film of cloud, and this is especially useful if you wish to reduce the contrast.

There are a number of ways of rendering the sun. It is the brightest part of your composition, and your brightest tone in a watercolour painting is the white paper itself (unless you are working on tinted paper), so it is best to keep the sun as a white orb on most occasions. Only now and then will I paint a weak yellow or red across it, and that is usually only over part of the orb. Often I simply paint the darker sky round the sun, in a negative manner, but masking fluid is an excellent alternative. You can use a coin or a plastic stencil that has a variety of circle sizes, or whatever suitable object that comes to hand, to draw the outline of the sun with a pencil. You can also lift out a circle from a damp wash by covering a coin with tissue and pressing it into the wash, but this method will not produce such a brilliantly white image as the others.

Chott el Gharsa, Tunisia

The camels appeared out of the remnants of a sandstorm as the sun was setting directly above them. I didn't need to change a thing in this watercolour sketch. As it rises or sets, the sun is much easier to paint, and can appear rather enormous. It can often be effective if you lose part of it, or part of the edge, in cloud or atmosphere.

Making the most of shadows

Cast shadows are by far the most effective way of suggesting a feeling of sunshine in your painting, so make the most of them: exaggerate, extend and enlarge them to your advantage. Shadows falling part way across a cliff or a bridge, for example, are especially exciting. Where you have a lovely white house, by all means push those trees closer in to give yourself an excuse to lay cast shadows over the walls and roof – it will breathe a little magic into your painting.

If you feel the shadow before you is too grey and boring, liven it up with a touch of red into whatever blue you are using. Lay these shadows across your already-painted feature once it has completely dried, and use them to describe the contours, ruts and other variations in the ground. When I am out working before nature, I try to place all the cast shadows at around the same time so that they are consistent – it is surprising how quickly that sun moves round and alters the angle and size of a shadow.

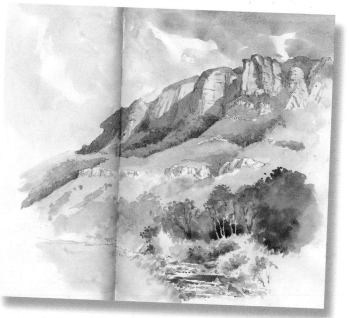

Cliffs in Natal, South Africa

Throwing shadows across cliffs, bridges or buildings is a lovely way of creating variety within a feature, and I watch out for the effect whenever the opportunity arises. I sketched these cliffs at 6.15 am and had no need to exaggerate the shadows, which I sometimes have to.

Alley in Portovenere, Italy

An ink and watercolour sketch done on the spot in an A4 sketchbook. I loved the way the alley turned slightly to the right as it went away. The shadow area makes the sunlit side look even warmer and sunnier. My only concern with this sketch is that I have made the closest figure slightly too large in proportion to the others. This can be a common problem where a number of figures are involved and one is trying to record figures before they get up and move away.

Reflected light

Reflected light is that which bounces off a surface that is in strong light, and is a weaker, secondary light. It works best when thrown off a white surface such as a white wall, a cloud, or an iceberg for example, but when strong light bounces off a coloured surface, that colour is also transferred as coloured reflected light. The reflecting surface may not always be visible in a composition. Reflected light can be useful to show up detail of secondary importance or to relieve a rather dull passage, but it also suggests a feeling of authenticity in your work. It is a well-used tool by photographers, and you can easily practise it on still life by holding up a large piece of white card close to the object on to which you wish to project the reflected light, allowing the light source to hit your sheet of card and bounce on to the object. Don't forget, you are in control of where the light bounces, so position it where it is most effective.

Polar Bear
32 x 47cm (12⅝in x 18½in)

Apart from a few rocks at sea level, all the rest is ice. There are a number of examples of reflected light in the scene, but the most prominent is the narrow vertical ice buttress just right of centre and directly above the small iceberg floating in the water. You can see how the lightest part of this buttress is at the bottom, nearest to the source of reflected light.

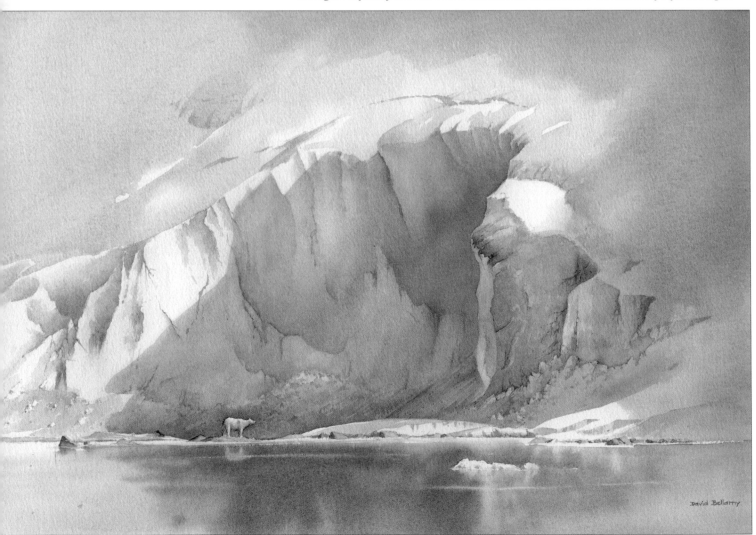

Reflected light on icebergs

Icebergs, like white clouds, are great reflectors of light and this photograph of giant icebergs illustrates well how ice walls in shadow can be lit up brightly in this way.

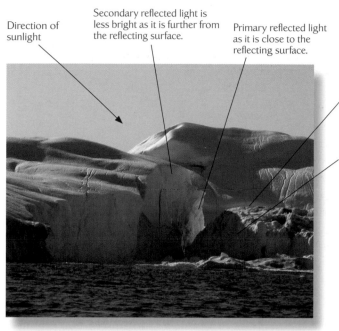

Direction of sunlight

Secondary reflected light is less bright as it is further from the reflecting surface.

Primary reflected light as it is close to the reflecting surface.

The reflecting surface is on the far side of this iceberg and catching direct sunlight.

Cast shadow.

BAR DUOMO

Via Santa Maria, Pisa

In this pen and watercolour sketch, the light is coming from the top right. Note the strong reflected light on the yellow wall above the deep red canopy. This will have been thrown up by the opposite wall. Note how it graduates into shadow.

Accentuating lighting

Both the illustrations on this page were done on the spot, and I was keen to make the light areas stand out, firstly by darkening the skies and trees to highlight the roofs, and secondly by strong definition on the buildings. Introducing powerful contrasts in this way is a superb method of heightening the drama of a work.

Cottage at Goathland, North Yorkshire
20 x 27cm (7⁷/₈ x 10⁵/₈in)

This was carried out on site as a demonstration and I wanted to illustrate how to accentuate the lighting, taking it from the mundane to the exciting. The dark trees made the tiled roof stand out, and creating a dark sky further highlighted the roof. There are a number of instances of strong tonal contrasts which further enhance the painting, and also I have employed counterchange on the fence and dry-stone wall, where each moves from light to dark, a powerful technique for creating interest and drama.

Sky wash applied first, bringing it down to work around the dome and the light roof.

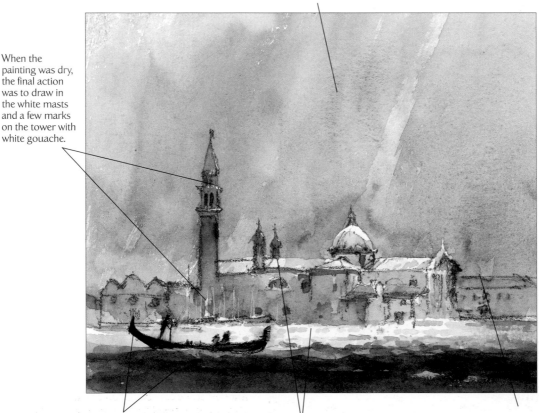

When the painting was dry, the final action was to draw in the white masts and a few marks on the tower with white gouache.

The dark foreground water and the gondola give a sense of drama and depth.

Middle distance water and parts of the roof left as bare paper.

Image drawn into the wet wash with a dark brown watercolour pencil.

San Giorgio, Venice
16 x 22cm (6¼ x 8⁵/₈in)

Quite a crowd gathered around as I did this rapid watercolour sketch while sitting on the quay. I wanted to capture the strong mood and intense light falling on the great building and the middle distant water. I drew with a dark brown watercolour pencil, mostly into the wet washes, which is an excellent method when speed is vital, as you don't need to wait for the washes to dry. The extremely strong darks in the foreground really make the white water stand out, at the same time introducing drama into the picture.

46

Tinted papers

If you wish to create a really strong sense of unity and mood in a watercolour, then try some on tinted papers. The Turner Grey paper is no longer made, but the painting below was done on Blue Lake paper, which is currently available. With tinted papers, any strong highlights have to be introduced with white, and my preference is for white gouache, which has a strong covering power. Both these scenes depict moonlight, which is always most effective over water or snow, and involves less detail and colour than with daylight landscapes. Try to avoid too many highlights. In each case, the actual colour of the paper is that of the light area next to the white of the moon. Tinted papers have a further advantage in that they will encourage you to leave some of the paper untouched.

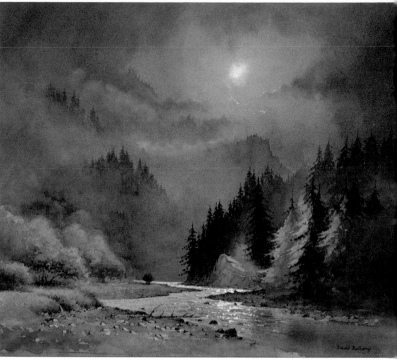

Moonlight on the River
23 x 29cm (9 x 11³/₈in)

I still have a few sheets of the old Turner Grey paper and this was used to create an atmospheric moonlight scene of the River Ystwyth in Wales. Tinted papers help to suggest unity in a painting, together with a strong sense of mood, and they are made by several manufacturers. The highlights were created with white gouache.

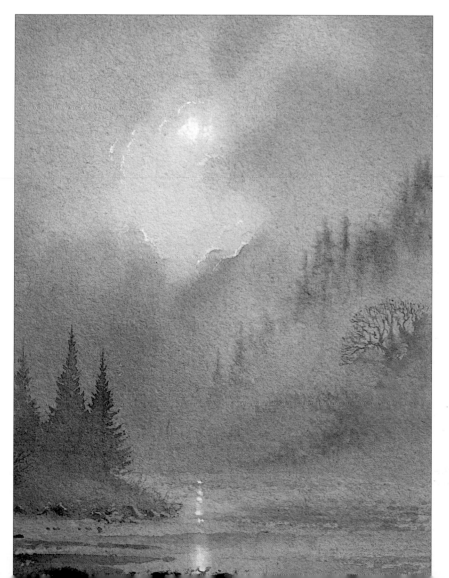

Lake by Moonlight

Another scene carried out on tinted paper. Everything is simplified in moonlight, and it helps if strong highlights are present, in the form of water or snow for example.

SUNLIGHT & SHADOW

Capturing a sense of sunlight in a painting can often elude us if we overwork the scene. It is vital to keep the painting fresh by using as few brush strokes as possible, and if you want to emphasise the sunny nature of a scene, nothing works better than cast shadows across simple, clean and uncluttered washes of reasonably bright colours.

Materials used

Saunders Waterford 640gsm (300lb) Rough watercolour paper

Brushes: squirrel mop, no. 10 round, no. 4 round, no. 1 rigger, no. 7 round

Colours: Naples yellow, cerulean blue, yellow ochre, French ultramarine, cadmium red, raw umber, cadmium orange, Winsor blue (red shade), cadmium yellow pale

1 Draw the scene with a 6B pencil.

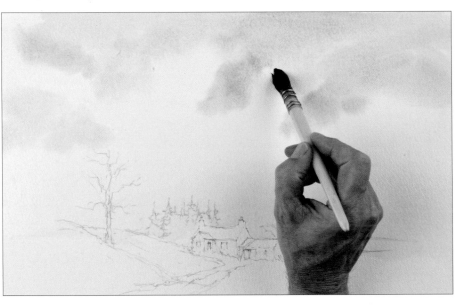

2 Wet the sky area and over the trees with the squirrel mop and drop in Naples yellow in the lower sky and cerulean blue higher up, leaving spaces for clouds.

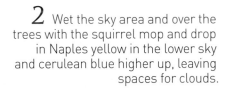

3 Warm up the lower part of the sky with yellow ochre, then strengthen the sky behind the house with French ultramarine and cadmium red on the no. 10 brush, suggesting cloud. Paint the stone of the outbuilding with the same mix, then drop in yellow ochre. Paint the fence area and the track with a pale wash of Naples yellow and leave the painting to dry.

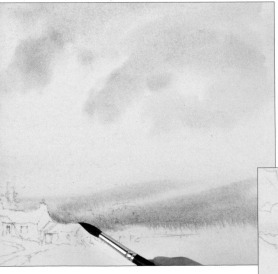

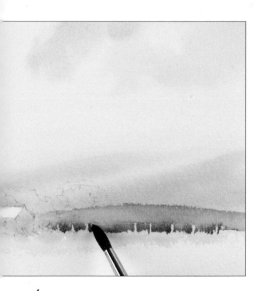

4 Bring out the fence by negative painting, using the no. 10 brush and raw umber to paint the field behind it.

5 Paint the roofs with cadmium red and French ultramarine. Drop a little cadmium yellow pale into the outhouse roof. Allow to dry, then paint the shaded gable ends and the cast shadow on the outbuilding with French ultramarine and cadmium red on the no. 4 brush.

6 Add a little architectural detail with the shadow mix, then paint the chimney pots with cadmium orange. Allow to dry.

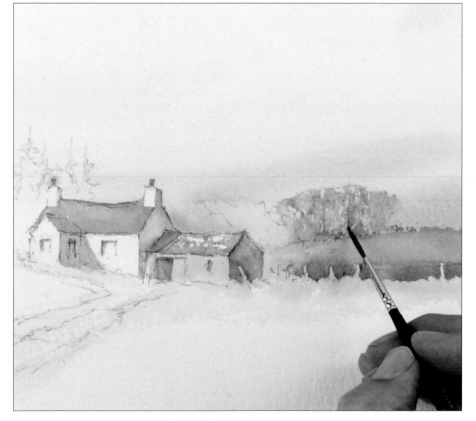

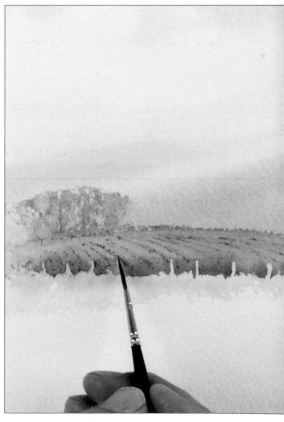

7 Still using the no. 4 brush, dry brush a mix of French ultramarine and cadmium red to create the distant stand of trees, then use the no. 1 rigger to put in a hint of detail.

8 Paint texture in the ploughed field with the no. 1 rigger and raw umber.

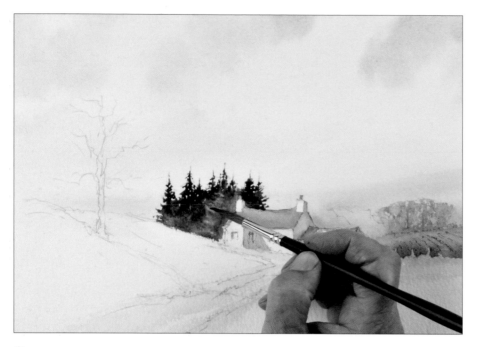

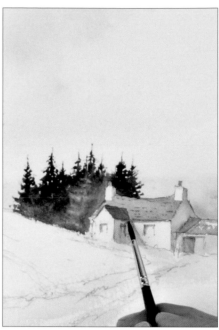

9 Mix Winsor blue (red shade) and raw umber and use the no. 7 brush to paint the conifers behind the house. While this is wet, use a damp brush to lift out some colour to create definition in the mass of trees.

10 Use the no. 4 brush and a mix of cadmium red and French ultramarine to paint the porch roof, and put in a touch of detail on the main roof of the house.

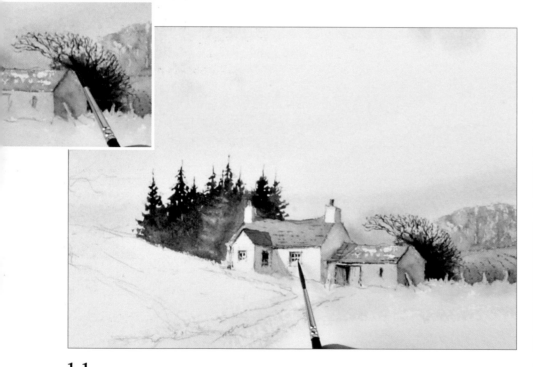

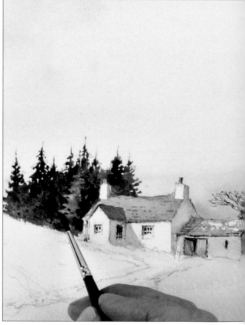

11 Paint the bush behind the outbuilding with cadmium red and burnt umber, using just burnt umber to darken it in places. Then use the no. 1 rigger and a mix of burnt umber and French ultramarine to paint delicate branchwork protruding from the bush. Use the same mix and brush to paint architectural detail on the house and outbuilding. Bright sunlight creates strong contrasts between the light outside of the buildings and the dark inside.

12 Make the outbuilding door look more rustic with a wash of cadmium yellow pale and a tiny touch of the conifer green – Winsor blue (red shade) and raw umber. With a no. 4 brush and the same green, add detail to the conifers.

13 Use the no. 10 brush and a mix of the conifer green with cadmium yellow pale to paint the grassy area on either side of the path. Use a fairly dry brush and leave flecks of white. Make the green stronger at the bottom of the painting, and add cadmium yellow pale on its own for sunlit grass. Add texture to the outbuilding with the no. 1 rigger and a mix of French ultramarine and burnt umber. Paint a shadow on the side of the path with the rigger and a mix of raw umber and French ultramarine.

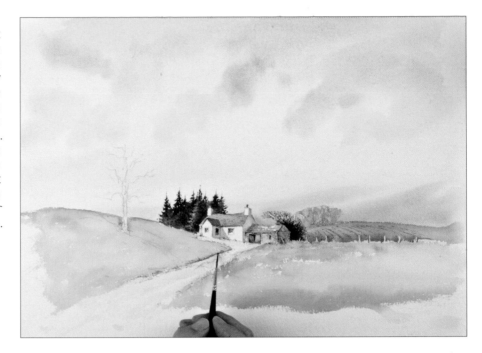

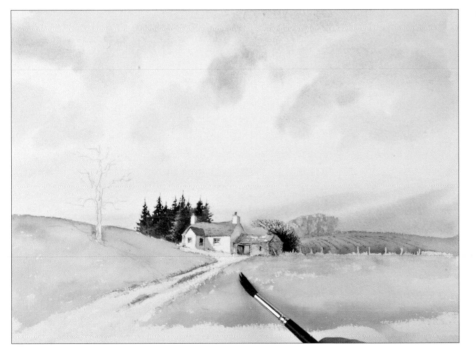

14 Paint a line of grass in the centre of the track with a mix of cadmium yellow pale, Winsor blue (red shade) and raw umber on the no. 1 rigger. Darken the shaded side with Winsor blue (red shade) and raw umber. Change to the no. 10 brush and wash over the grass on either side of the path with cadmium yellow pale with a bit of the darker green mix.

15 Paint the winter tree on the left with French ultramarine and raw umber on the no. 4 brush, then drop in yellow ochre. Change to the no. 1 rigger and paint the branchwork with raw umber and French ultramarine.

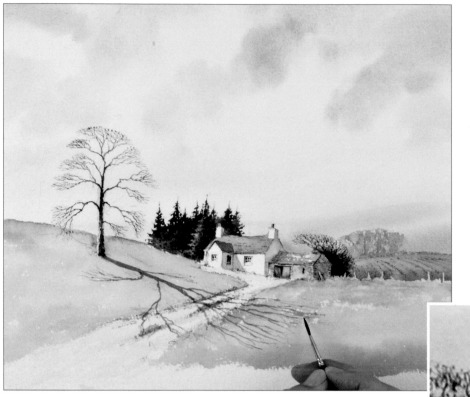

16 Use the no. 4 brush and a mix of French ultramarine and cadmium red to paint the cast shadow from the tree. Change to the no. 1 rigger for the finer parts. When this dried, it appeared too stark, so I weakened the shadow with a damp sponge. To add a little life, put in crows flying above the distant trees with French ultramarine and burnt umber.

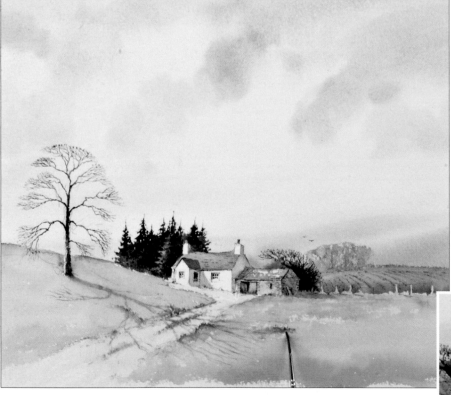

17 Still using the no. 1 rigger, paint clumps of grass to break up the grassy area with raw umber and French ultramarine. Scratch out the wire for the fence using the point of a craft knife blade.

The finished painting.

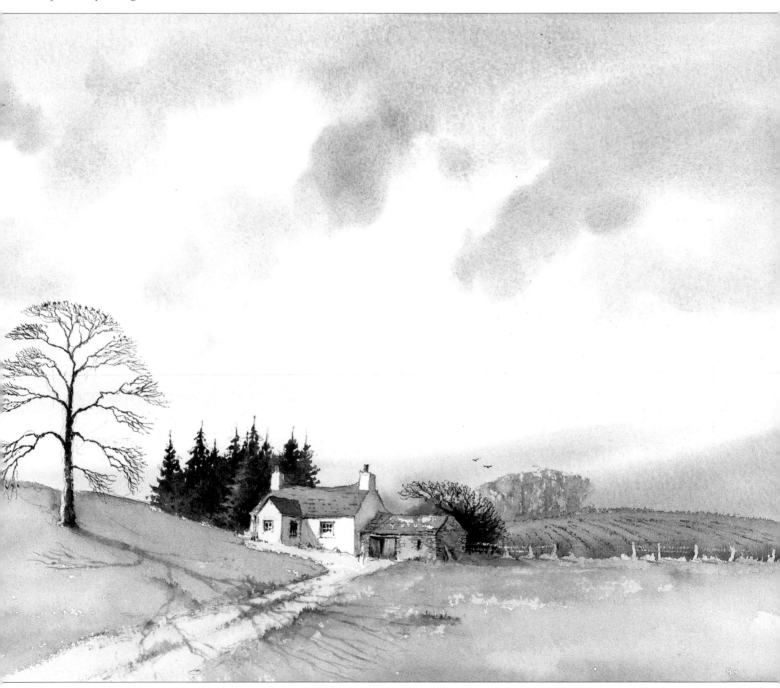

Atmosphere

Mood or atmosphere is the icing on the landscape cake. When used with thought, it can totally transform a scene, and can inject a sense of power and drama at the same time. In this section you will see how we can enhance a 'normal' landscape into one conveying the power and beauty of nature's finest moods, how we can use it to lose unwanted detail, or suggest mystery, impending doom, a light, airy afternoon, tranquil moments, and much more.

Mood can be especially effective in highlighting a centre of interest or suggesting a narrative. The methods and combinations of techniques that follow will provide you with the necessary skills and information to heighten the emotional power of your paintings and set you thinking about how you are going to introduce this element into each one. You can try any number of these methods on the same composition and completely change the mood of the original scene if you wish. Try to get out of the habit of always painting fields green, clouds white, or mud brown – flood the whole composition with a colour mood to suit your idea, even if it conflicts with the colours we normally assume to be correct. Those who fail to see pink mud are truly restricting their imaginative palette.

Morning Mist, River Wye
27 x 40cm (10⅝ x 15¾in)

Mist is an effective tool in creating atmosphere, as well as losing details that are superfluous. To make the most of it, place a strong, sharp feature in front of it to contrast with the soft, misty shapes beyond – as with the cattle and the closer trees in this scene.

David Bellamy

Basic methods of creating atmosphere

There are numerous methods of enhancing or creating a moody scene, and here we will look at some of the most powerful ways of injecting that atmospheric quality into your landscapes. The first thing you should consider when trying to decide on a mood is whether it should be a light, airy feeling, or sombre, dark, threatening, tranquil, restless, perhaps even sinister – in fact whatever you feel most fits your subject and the manner in which you wish to portray it. Then you can look through the pages of this book, and others, to see if any ideas for moody treatment strike you.

Unity of colours

Setting Sun, Luxor, Egypt

With the sun sinking fast, I had no time to mess about. Unity of colours and a limited palette are vital to creating a sense of mood, and this rapid sketch on cartridge paper is mainly a work of French ultramarine mixed with cadmium red, leaving the highlights as untouched paper. For the warmer part of the sky, I used cadmium orange, plus a touch in the sun, and also a few splashes of Naples yellow. The orange was crudely applied at the last minute, and I should have softened off the lower half of the sun, but sketching a scene like this, however crude, will give you excellent experience at rendering atmosphere.

Creating a light, airy mood

Stone Bridge
19 x 28cm (7½ x 11in)

Here dark foreground features set against a high-key background suggest a lovely sunny, airy atmosphere, further emphasised by flecks of white paper appearing in many places, and especially the top of the bridge parapet.

Sombre mood

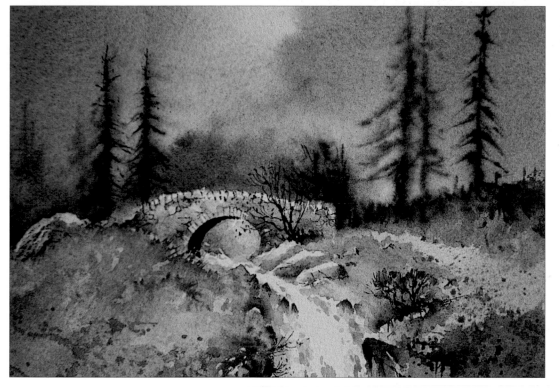

Woodland Bridge

This small work shows the value of hard and soft edges: the background has been kept soft, thus throwing the emphasis on to the focal point – the bridge, with its hard edges. This stands out strongly against the dark, wet-in-wet woodland. I used masking fluid to retain the whites on the bridge detail.

Suggesting detail

Maasai Girl

Iambeini was out collecting water in the Olkarien Gorge, Tanzania, with her donkeys when we met her. She was shy about posing, but seemed to enjoy the encounter once she became used to us. There was much intricate rock detail in the background cliffs, which I have subdued in places and completely lost in others, especially around the figure and her donkeys.

Using atmosphere to suggest space and distance

In any landscape the most powerful tool at your disposal for creating a sense of space and distance is that of atmospheric or aerial perspective. While cool colours recede, you can still paint fairly warm colours in the distance provided you have warmer colours or stronger darks in the foreground. You can see how the effect of strong tones and more highly-defined detail in the foreground of the Amsterdam watercolour create the sense of depth when just using one colour.

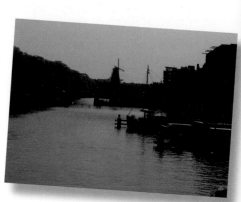

Windmill

This photograph of a windmill in Amsterdam reveals very little colour, which often occurs in back-lit scenes, and is the subject of the accompanying sketch.

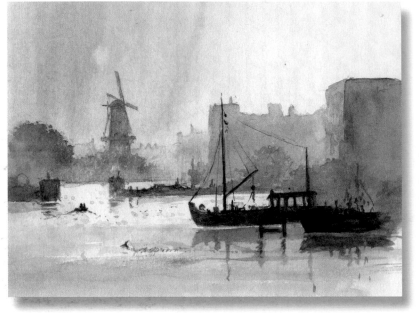

Windmill in Amsterdam

A watercolour sketch of the scene in the photograph, carried out in an A4 sketchbook of cartridge paper. As there was so little colour in the back-lit scene, I decided to carry this out in monochrome, an ideal way of suggesting mood and unity in a scene. It is much simplified and I have altered the positions of one or two features. The rowing boat went past as I sketched, a few minutes after I had taken the photograph.

Pennine Barns
28 x 47cm (11 x 18½in)

The atmospheric perspective in this watercolour is enhanced by the soft, cool colours in the distance. These contrast with the warmer foreground colours. Note how the left-hand wall diminishes and loses much detail as it recedes into the distance on the far left.

Haze and light mist

If you are painting in hot, desert-type scenery, you may not get mists or fog, but a heat haze is equally effective at reducing background detail. Utilising a light haze in a watercolour is something I do fairly often, otherwise everything stands out in such stark detail that features tend to look as though they are running into each other. I am particularly fond of the light sea mist that invades beaches at low level, as in the Solva painting below. Long beaches with high cliffs are especially good places to find the phenomenon.

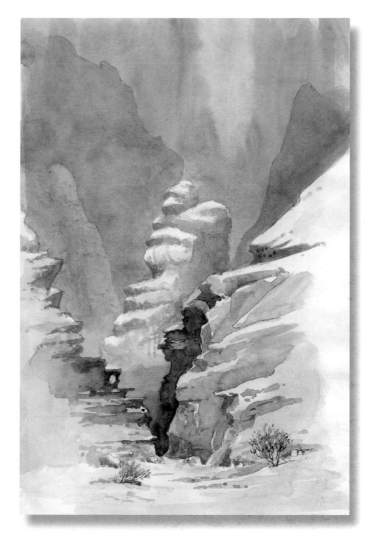

Khazareh Canyon, Jordan

This is a watercolour sketch done on an A4 cartridge sketchbook. Background haze is suggested by soft edges and a single blue-grey colour set against the warm reds in the foreground. This dried so quickly in the intense heat that the hard background edges to the washes had to be sponged off with a soft, natural sponge when I returned to the tent later. The sponge is an excellent tool for creating mist.

Early Morning, Solva
21 x 31cm (8¼ x 12¼in)

The feeling of low-lying mist in this Welsh scene is created by showing only the tops of the cottages, and by the stronger detail on the boats that are closer to the viewer. Light mist can be extremely attractive when combined with sunlight filtering through and perhaps sparkling on the water.

Fog

By far the best method of depicting fog is the wet-in-wet technique. With strong detail and sharp edges on any foreground features, the foggy effect can be dramatically emphasised. The secret to using this method effectively is to flood the paper with a fluid wash over the area where you wish to create the fog, then allow it to start drying. I like to mix all my washes before starting this process, otherwise the first wash may dry too much before I am ready. The second application of colour, which in the example below would be the fainter background trees and the dark area that defines the roofs, must be a strong mixture without any excess water. Only experience will show you exactly how damp it should be, and how long to wait before applying this second wash. You can test the wetness of the first wash with small dabs of the second colour and check if it is giving you the effect you are seeking, then go for it once you are confident it is just right.

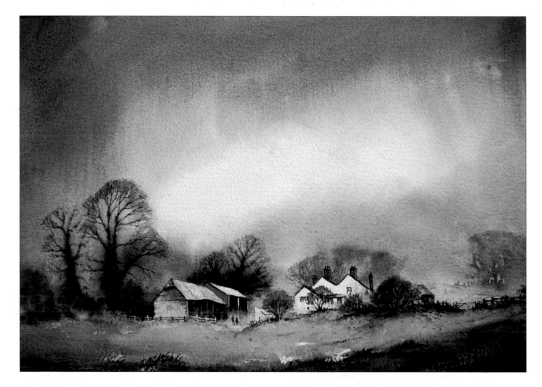

Farm on the North Downs
45 x 60cm (17¾ x 23⅝in)

Foggy days can provide interesting and atmospheric compositions. In this scene I was mainly interested in the rustic barns on the left, and when the painting returned from framing, I realised how much better it would have been to have subdued the farmhouse a little to throw more emphasis on to the barns.

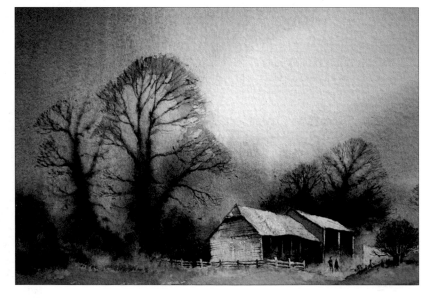

Detail of the painting
In this close-up of the barn, the damp light is suggested by the light-toned roof that undulates delightfully. I graduated the gable end of the building, a method that adds interest without cluttering up a passage, and subdued the urge to paint in too many boards. Note the counterchange on the fence, caused by the background tone changing. The backdrop to the scene was achieved with the wet-in-wet application of washes.

Losing part of a mountain in cloud

Obscuring part of a hill or mountain in cloud is an excellent way of creating atmosphere, breaking up a monotonous ridge, or providing more emphasis to an adjacent crag or summit that is left clear of cloud. The effect can be achieved in a number of ways. A common problem occurs at the completion of a painting when you may well realise that the continuous sharp-edged ridge would work better had it been broken up with a puff of cloud or mist. In this case I often sponge out part of the ridge with a soft sponge and clean water, if necessary shielding an important part with a sheet of paper.

The most usual method of creating a mist-shrouded summit is that shown in the illustration, where the part of the mountain to be obscured was washed with clean water, which was also taken across the adjacent sky, and then the mountain colour was drifted into the wet area to create a soft transition. You may find that you need to redefine an edge by pulling out colour with a large, damp, round brush while the paper is still damp.

A third method is to paint in the summit, crag or feature that you wish to obscure, but do it faintly and perhaps leave out part of it completely. When this is dry, lay clean water over it and the adjacent sky – here it pays to go well beyond where you think the water will reach – and then apply a weak wash of the colour you want for the cloud or mist. This will act as a glaze, allowing the painted feature to show through, but making it less distinct than the rest of the mountain. Used effectively, this is a superb technique for suggesting that there's 'something up there.'

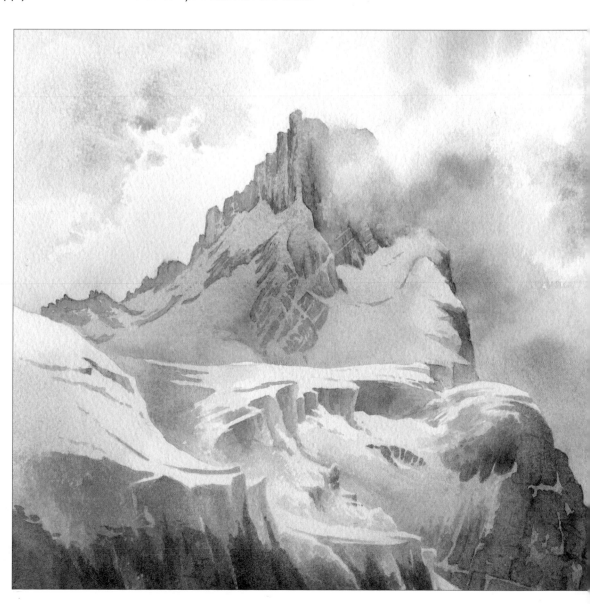

Cumbre Principale, Chile
28 x 35cm (11 x 13¾in)

Often a painting is improved by leaving out certain details, and this is a useful device where a mountain is too dominant or shows too much detail. In this watercolour, the summit is partly obscured by cloud. This effect was achieved by wetting the area to be obscured, plus the adjacent sky, then drifting the mountain colour into the area. It often helps to take out some wisps of colour with a damp round brush, and this can suggest movement and variation in the cloud or mist.

Creating mist among crags

When painting a complicated scene like this gully in winter, it is best to break it down into several stages and not feel overwhelmed by sheer detail. Misty backgrounds will lack colour variety, so tonal variations applied wet in wet are best, only bringing in the warmer colours when you get closer to the foreground. Simplify as much as you can by only including the main features.

1 I applied a wash of Payne's gray with a touch of burnt umber over the background and running into the sky, then almost immediately a darker mixture to suggest the background crags and to define the wraith of mist, working wet in wet into the first wash.

2 When the paper had dried, I painted in the main crags, dropping some yellow ochre in while they were still wet, and leaving the snow areas untouched. I also dropped in a touch of light red to give the central cliff a bit of a lift. Then I applied some cobalt blue over the snow areas, leaving some of the paper untouched to appear as white.

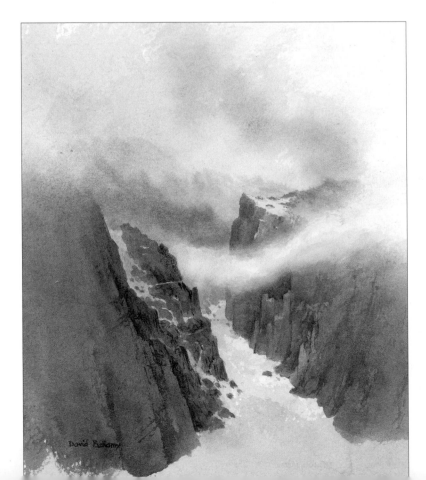

3 I wet the paper above the left-hand cliff and laid a wash into it to suggest the soft transition. I then wet the top right area and added a little more tone, again to create this softness that is so vital in suggesting mist-clad crags. Before completing the piece some further details were added to define gullies and fractures.

Mist and sunlight patches

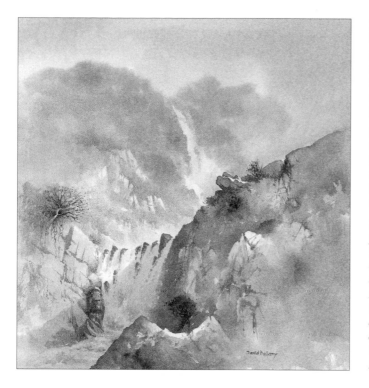

Helvellyn Gill, Lake District
22 x 20cm (8⁵/8 x 7⁷/8in)

Strong foreground definition, a light, misty background plus a hint of weak sunlight can combine to create an attractive way of improving a scene. This is a method I often introduce to change an otherwise ordinary landscape into one of intense mood and perhaps a touch of mystery.

Invariably in an instance like this I will do at least one thumbnail sketch to indicate where the main features will appear, how and where they will be lit up, where the mist will introduce the air of mystery, and most importantly, how much will be revealed in that misty background. Only when I am happy with the arrangement do I begin work on the watercolour.

In this painting the background directly above the waterfall was painted first, on dry paper, leaving the light rocks absolutely white. When this was dry, I applied a weak wash of ultramarine and cadmium red over the background, avoiding the white cascade, coming down over the already defined rocks – and thus slightly muting them - and adding some cadmium yellow pale just above the falls. Taking a stronger mixture of the same colours, I then defined the darker background cliff wet in wet, again avoiding the cascade. When all this was dry, I painted in the waterfall and all the foreground, leaving the shadow of ultramarine and cadmium red until the very end.

Smoke and steam

Steam obliterates detail

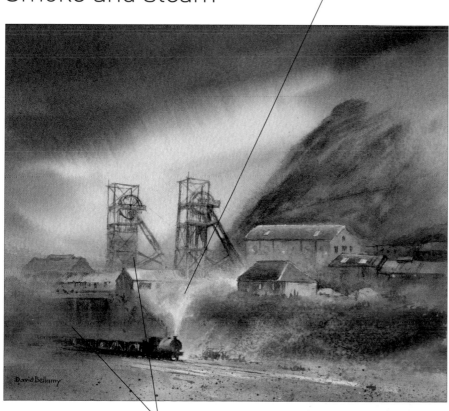

Detail reduced in atmosphere

Steam at Markham Colliery
18 x 21cm (7¹/8 x 8¼in)

Man-made smoke and steam can be effective in losing detail where it becomes overwhelming, or where you may wish to make a certain feature stand out. It is also a great device when you are not sure what is actually happening at some point in the painting. This works especially well with industrial subjects.

An alternative method to wet in wet for creating atmosphere

Layering is a useful alternative to the wet-in-wet technique, especially where you may wish to suggest a weak, but reasonably sharply defined background feature. It is simply a series of layers, or glazes, laid over an already painted area, and is invaluable in suggesting an ethereal mood.

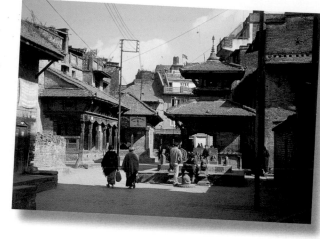

In this photograph of Bhaktapur in Nepal, there is far too much detail in the actual scene, especially in the background, and in the painting I wanted to introduce a sense of atmosphere.

Bhaktapur in Early Morning Light
25 x 32cm (9⁷/₈ x 12⁵/₈in)

I began by laying in the shapes of the background buildings with weak blue-grey washes, with a hint of detail in the bottom centre and the left-hand side above the sloping roof. When these were dry, I laid a weak, transparent layer of French ultramarine with a touch of permanent alizarin crimson over the already painted areas. Next, the building above the four figures in saris was rendered and the tall far-right one. Again I repeated the layer of transparent weak colour over these additions, to further emphasise the film of atmospheric mist. Much stronger detail was then introduced to the foreground buildings and the main figures were painted in, with the cast shadows providing a strong feeling of directional sunlight. In addition to invoking a feeling of mist, this layering or glazing technique is ideal for conveying unity to an area of the painting, however large.

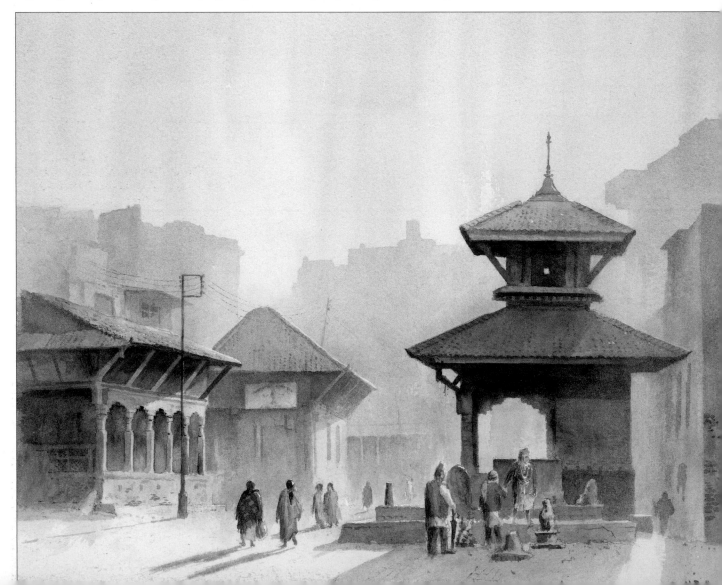

Rain squalls

The glaze technique shown in these stages can create an exciting illusion of a rain squall, but try it out on your old 'failed' paintings first to gain confidence.

1 I painted a weak wash of Naples yellow over the lower sky and hills, with yellow ochre in the foreground area. To suggest the shadow side of the clouds, I applied a wash of cobalt blue and perylene red into parts of the Naples yellow while it remained wet, so that the edges were soft. Then, before allowing the paper to dry, I brushed some cobalt blue with a weak touch of burnt sienna into the centre part of the sky.

2 On dry paper I laid a wash of French ultramarine and burnt sienna to describe the hills.

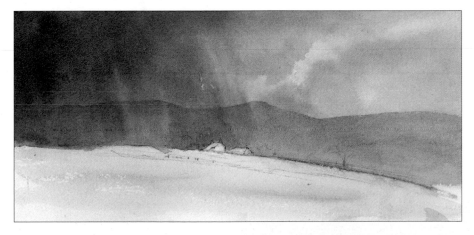

3 Once again I let the paper dry completely before continuing. I then wet the sky and hills and dropped a strong mix of French ultramarine and cadmium red into the left-hand side, bringing it down over the hills. I kept the board at a fairly steep and slightly diagonal angle to allow the wash to run down over the hills, like rain sweeping across the landscape.

4 I painted in the farm detail and trees, mainly with raw umber and French ultramarine, then the foreground with burnt umber and cadmium red. Practise this technique on scrap paper until you feel confident with it.

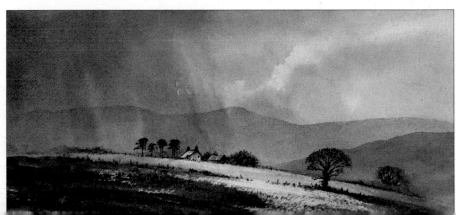

Falling rain

Being too literal can destroy the effect in many paintings, and with falling rain it is vital not to overstate the impression with strident vertical strokes. A few light strokes against a dark patch is often quite enough to suggest rain. Likewise, limit the number of ripples caused by raindrops falling on to a puddle.

Rain

It is the easiest thing in the world to overwork falling rain. There are a number of ways of depicting this, apart from that of the glaze method shown earlier for the distant rain squall. Here we look at how to tackle falling rain close up, but always remember to economise with the amount of detail.

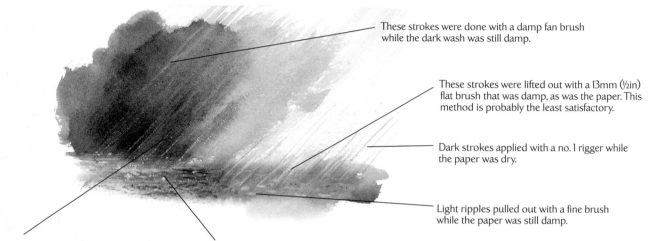

These strokes were done with a damp fan brush while the dark wash was still damp.

These strokes were lifted out with a 13mm (½in) flat brush that was damp, as was the paper. This method is probably the least satisfactory.

Dark strokes applied with a no. 1 rigger while the paper was dry.

Light ripples pulled out with a fine brush while the paper was still damp.

The more prominent strokes were achieved by scratching out with a craft knife on dry paper.

White blobs stabbed out with a craft knife on dry paper.

Cobbled Lane, Hackney
24 x 15cm (9½ x 5⅝in)

There is no better way to suggest a damp day than to create reflections on the pavements, ideally breaking them up, as in this small watercolour, with slivers of light and the inundations of the partly-cobbled street. An umbrella instantly shouts 'rain', even if you do not actually describe the rainfall, as here, and a hazy blue-grey background provides dim, distant shapes seen through light rain or drizzle.

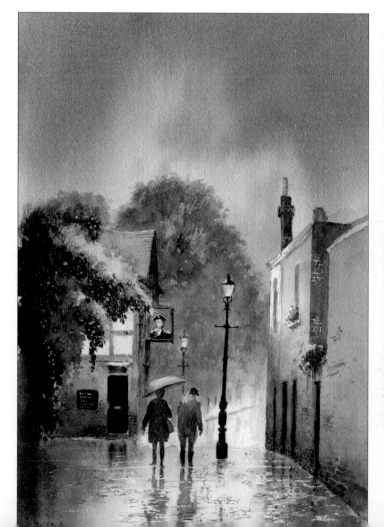

Colour emphasis and mood

When you are considering what sort of mood to apply to a painting, it is important to think about your choice of colours and how the overall colour effect will influence the viewer's response. At this point I decide whether the overall impression is to be warm or cool, and if I intend to use tinted paper, the tint will have a strong bearing on this. In the painting below I chose de Wint paper because I wanted a warm mood. Note how the slight shadows on the front of the castle have been achieved not with a cool blue, but a warm red. Don't always go for what may seem to be the obvious colour choice.

Laugharne Castle
20 x 28cm (7⁷/₈ x 11in)

This watercolour was painted on biscuit-coloured de Wint paper, which is no longer available. The moody sensation has been created by the two dominating colours: the light ochre on the castle, which was aided by the tint of the paper, with echoes on parts of the sky and ground, and the murky purple clouds billowing in the background. The colours have been heightened in places with dabs of cadmium red on the castle, cadmium yellow pale on the flat surface of the ground, and Winsor blue on the boats.

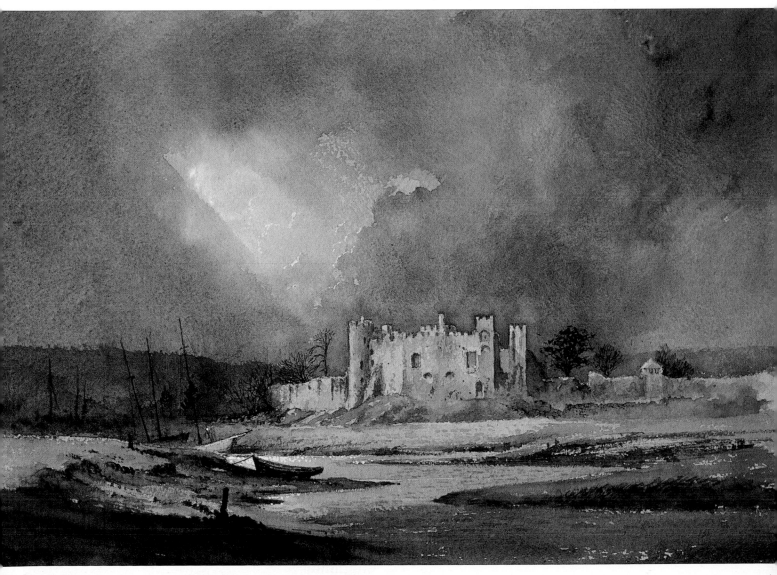

Storms

Storms come in many forms, and some of the most exciting involve strong contrasts of light and dark, often with a directional light from one side. Use the glazing technique to subdue background features, allowing them to show only faintly through the overlaid transparent wash. Get out your old paintings that you feel have been failures and think about overlaying a storm on them by applying glazes and dark swathes of sky. A strong diagonal emphasis in the sky further helps to suggest stormy, windy conditions.

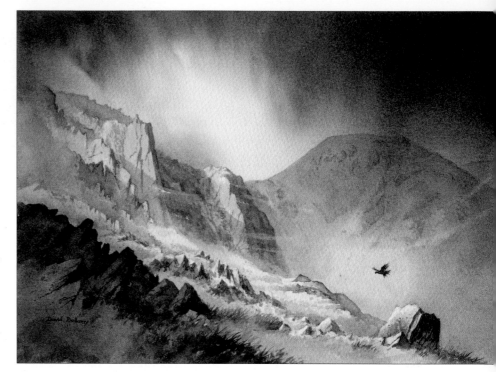

Storm over Scafell Pike, Lake District
20 x 28cm (77/8 x 11in)

In a painting the effect of a storm can be heightened by introducing a strong highlight to counter the dark, menacing atmosphere. Here I have included strong directional lighting.

Wind

Whether you aim to depict a gentle breeze or a life-threatening hurricane, you will need to be consistent with your details. Make sure each tree, bush or blade of grass, and any driven rain is blowing the same way – it might seem rather basic, but I have seen paintings where the wind appears to be blowing in opposite directions at the same time.

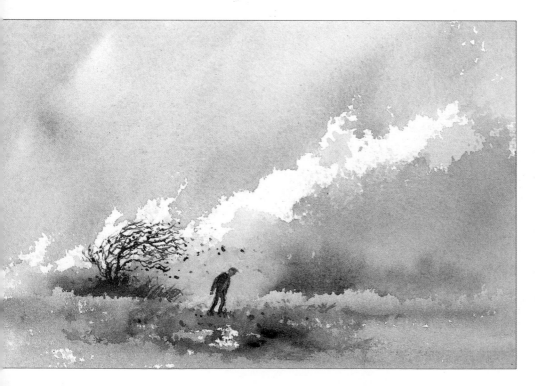

Windy Day

Trees, bushes and long grasses bent before the wind are the ideal method of showing the strength of the wind, and here I have added a figure leaning forward for emphasis. Diagonal cloud formations with ragged edges further enhance the windy effect. Animals such as sheep, horses and cows tend to turn their backs to the weather when standing in a field.

Snow and hoar-frost

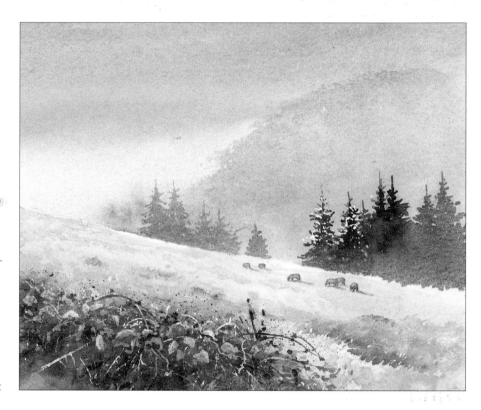

Frosty Morning
15 x 19cm (6 x 7½in)

You will find different degrees of hoar-frost, depending on the severity of the temperature, and in this scene the light frost fails to completely eliminate the green of the grass, simply subduing it a little. Not all the vegetation becomes stark white, as some parts are more exposed than others, and by including some warm-coloured parts, I have made the rest look even colder.

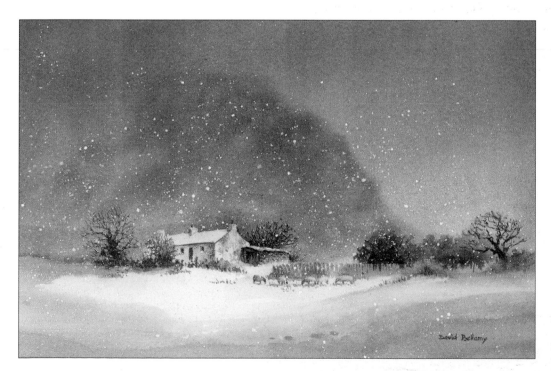

Snowfall
17 x 25cm (6⅝ x 9⅞in)

In this gently-falling snow scene I have used a toothbrush to spatter white gouache across the watercolour after completing the details and allowing the paper to dry. To achieve more depth you could spatter water or white gouache over the painting while it is still slightly damp, then allow it to dry before spattering the main application of white gouache. Do not over-do the initial spattering.

Creating tranquil moods

While wind, storms and dramatic scenes rely on diagonals and vertical emphasis, to convey a sense of peace and tranquillity, we need the emphasis to be on a more horizontal composition.

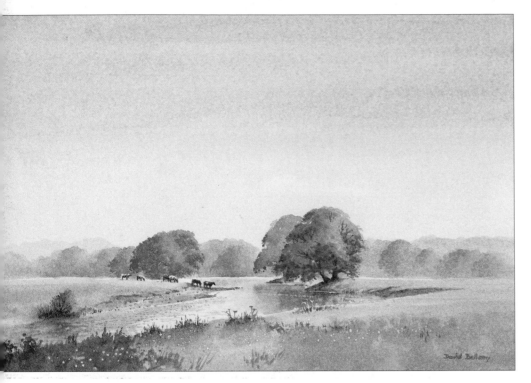

River Wye in Summer
20 x 29cm (7⁷/₈ x 11³/₈in)

To suggest a tranquil mood, it is hard to beat a placid river with reflections, and the cow is normally one of the most calm-inducing of animals. In this small watercolour I have combined these two elements and kept the whole scene devoid of strident verticals.

October Evening
13 x 21cm (5¹/₈ x 8¹/₄in)

Here I have conveyed the warmth of a peaceful autumn evening where a rusting old farm implement lies in the undergrowth – another way of introducing a sense of tranquillity and a sense of escape from a hectic world.

Village atmosphere

In a village or town, although you are perhaps painting a scene with much less depth than a wide landscape, you still need to lose background detail and suggest a sense of space and depth. This can be achieved by losing most of the detail on features that are positioned behind other objects, whether buildings, vehicles or people, regardless of how clearly you can see the scene.

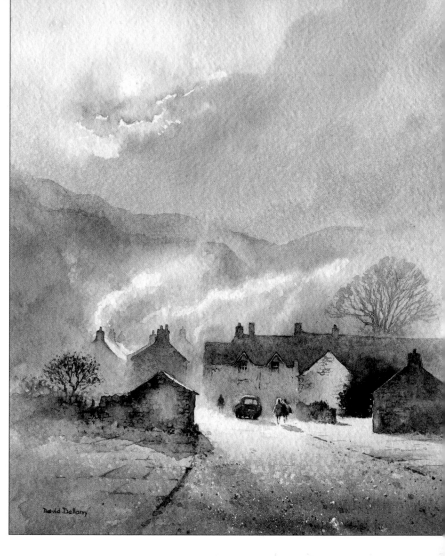

Morning Light, Bradwell
27 x 22cm (10⅝ x 8⅝in)

With back lighting, the halo effect round the figures where the sunlight catches them can really bring them to life. Blonde or light-coloured hair can be especially scintillating against the light. By contrast the figure in shadow is quite subdued, so it pays to think carefully before you place any figures in a composition, particularly if you want them to stand out.

The advantages of dust, dirt and sand

Dust stirred up into the air can be an effective means of losing detail and providing a hazy, mysterious background. Trucks driven across the desert or along a dusty track are generally followed by clouds of dust, so make use of this effect whenever you can, as it can also imply movement.

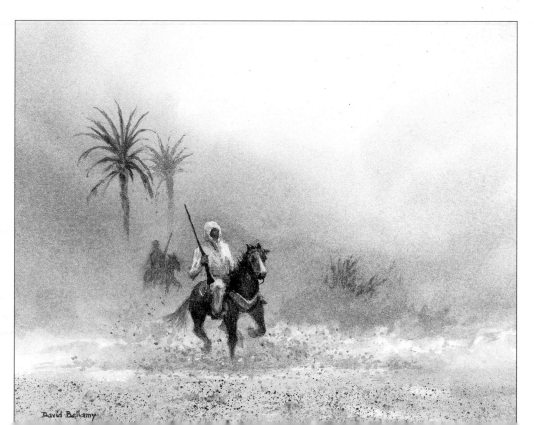

Moroccan Horsemen
19 x 19cm (7½ x 7½in)

Dust is an extremely useful commodity for losing detail, especially in the case of riders, and here it helps to convey a sense of movement in the horse's legs.

WATERFALL

There is nothing quite like the wet-in-wet method for creating a misty, atmospheric background, and in this demonstration we also see how to tackle mist caused by spray, creating a lost and found backdrop directly next to the waterfall.

Materials used

Saunders Waterford 640gsm (300lb) Rough watercolour paper

Brushes: squirrel mop, no. 1 rigger, 6mm (¼in) flat, no. 10 round, no. 4 round, no. 7 round, 13mm (½in) flat

Colours: Naples yellow, French ultramarine, burnt umber, yellow ochre, cadmium orange, cadmium red, cadmium yellow pale

Masking fluid and old brush

Sponge

Paper mask

1 Draw the scene. Use masking fluid and an old brush to mask the foliage, which will be lighter than the background, the trunks of the small trees on the right and a few splashes in the water around the cascade. Allow to dry.

2 Wet the background and sky with a squirrel mop, then drop in Naples yellow in the top right-hand sky, then a mix of French ultramarine and burnt umber around this, working wet in wet. Next wash French ultramarine over the left-hand side. Soften any edges with a damp brush if they become too harsh.

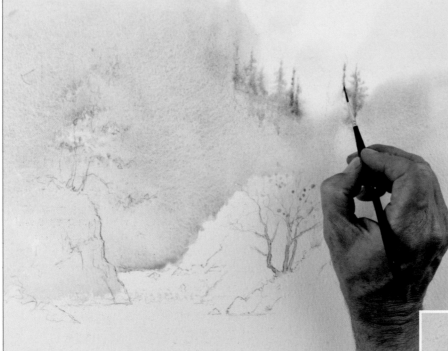

3 Define the edge of the waterfall. Still working wet in wet, pick up a strong mix of French ultramarine and burnt umber on the no. 1 brush and put in the distant conifers showing through the mist. Soften any edges with a damp 6mm (¼in) flat brush if they become too harsh. Wash and blot the brush again and use it to lift out colour to create wisps of mist.

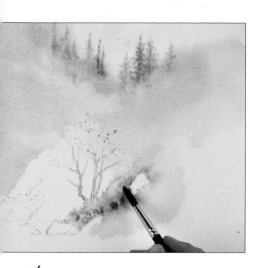

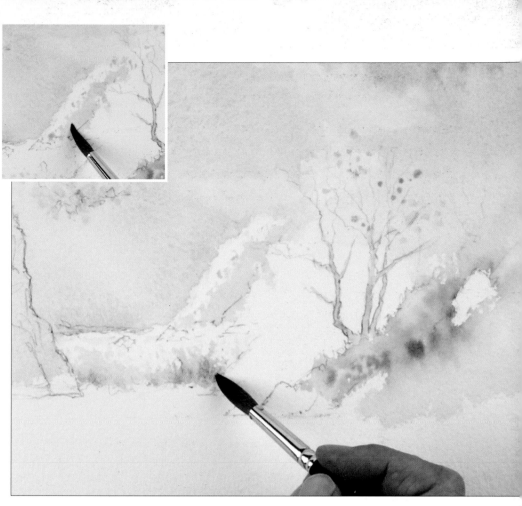

4 Use the no. 10 brush to paint the right-hand bank with yellow ochre, then drop in cadmium orange in places. While it is wet, drop in a mix of cadmium red and burnt umber.

5 Suggest the crashing water of the waterfall with French ultramarine. Use the rough texture of the paper to imply the frothing water. Add burnt umber to the mix in the lower falls to darken it a little above the white water created by the falling water crashing into the pool.

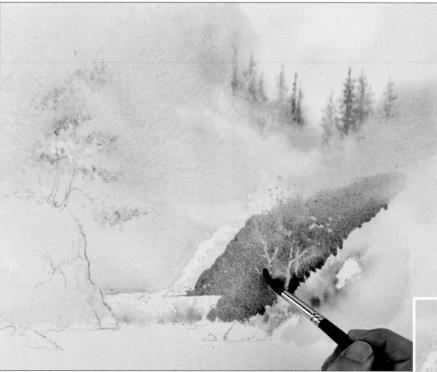

6 Wet the area behind the right-hand bank and apply a medium-toned mix of burnt umber and French ultramarine, taking it down to the water and fading it off into the mist above. Define the edges of the lighter bank using negative painting. Drop in yellow ochre while the grey is wet. Soften the top edge of the lighter bank with a damp brush.

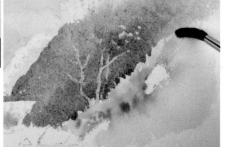

73

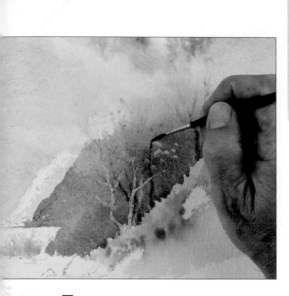

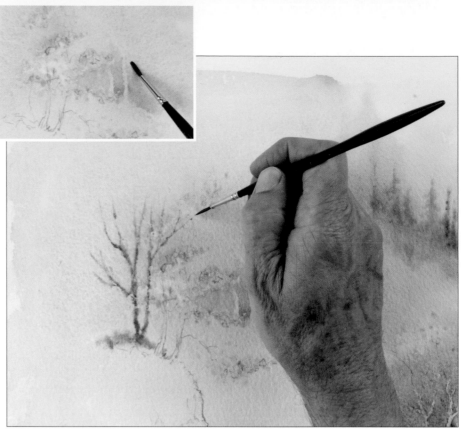

7 While the background is wet, use the no. 1 rigger and a strong mix of French ultramarine and burnt umber to describe the background trees.

8 Mix a pale grey from burnt umber and French ultramarine and use the no. 4 round brush to paint negatively, suggesting misty tree trunks behind the main trees on the left. These are not included in the pencil drawing. Change to the no. 1 rigger and paint the trees slightly further forward with a stronger mix of the same colours.

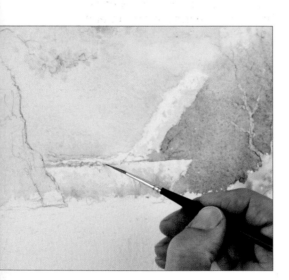

9 Use the same brush and a weaker mix of the same grey to define the pool by suggesting the waterline.

10 Use the side of the brush and the same mix to create texture on the the rock on the right-hand bank, then straight away drop in cadmium yellow pale for lichen.

11 Use the no. 7 brush to paint yellow ochre on the left-hand bank, then while this is wet, drag down a mix of French ultramarine and burnt umber with the brush on its side. Define the edges of the bank. Drop in more yellow ochre.

12 Use the no. 4 brush to paint the rocks in the pool with a dark mix of French ultramarine and burnt umber. Continue into the banks on the right.

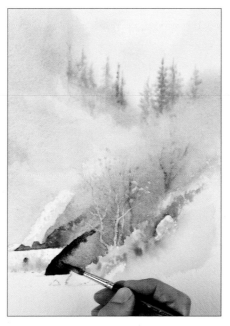

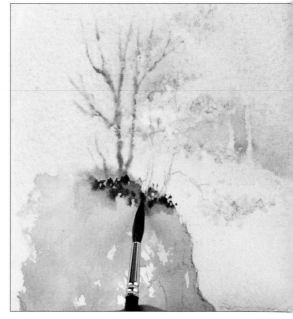

13 Using the same brush, paint negatively behind the rock in the right-hand bank with burnt umber, to make it stand out.

14 Dampen the bank behind this one and darken the edge with the no. 7 brush and a mix of French ultramarine and burnt umber. Drop in cadmium yellow pale to suggest moss.

15 Suggest fallen leaves on the top of the left-hand bank with cadmium orange, then a mix of cadmium red and burnt umber.

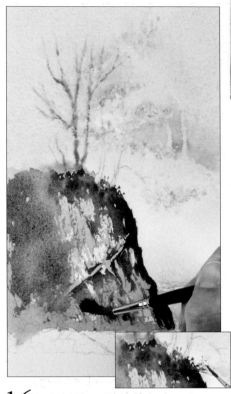

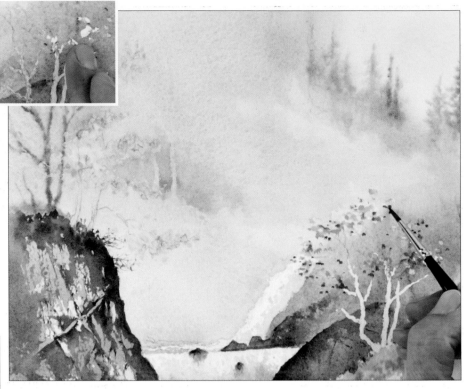

16 Use the no. 10 brush to drag down a mix of French ultramarine and burnt umber to darken the tone of the bank and bring it forwards. Change to the no. 1 rigger and use the same mix to describe fracture lines in the rock and hint at vegetation protruding from it.

17 Rub off the masking fluid from the right-hand trees. Use the no. 4 brush to paint foliage with cadmium orange, then cadmium yellow pale, allowing the yellow to run into the orange in places. Continue painting foliage with touches of burnt umber.

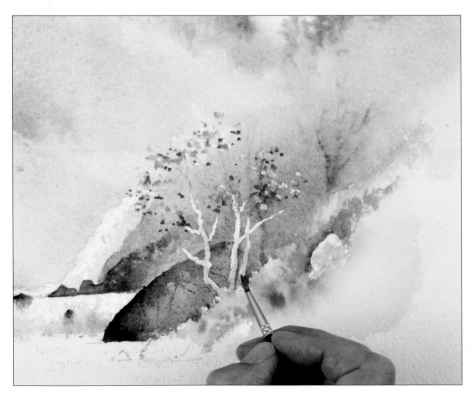

18 Paint a very weak mix of French ultramarine and burnt umber on to the lower tree trunks and drop in cadmium yellow pale at the bottom.

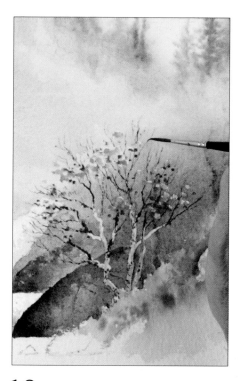

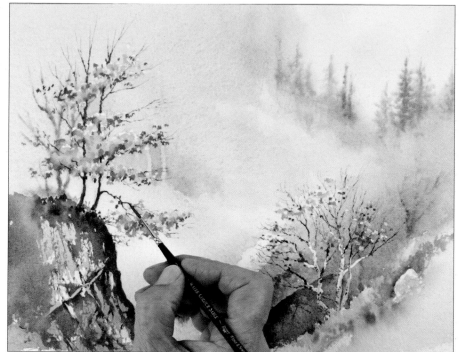

19 Use the no. 1 rigger and a dark mix of French ultramarine and burnt umber to paint the delicate branchwork of this right-hand tree.

20 Remove the masking fluid from the left-hand tree and paint the foliage, using the same sequence of colours as in step 17. Change to the rigger brush to paint the branchwork as for the right-hand tree.

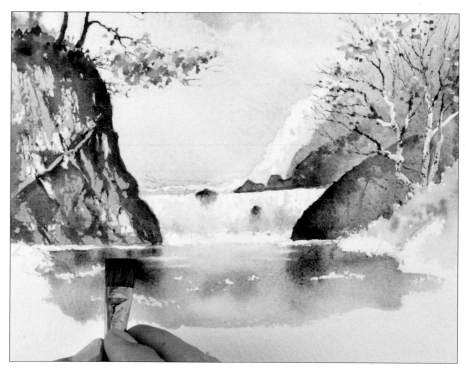

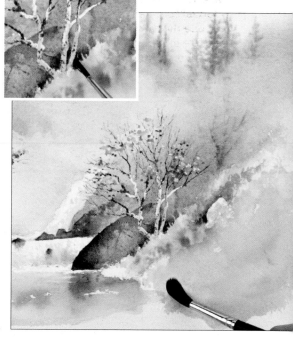

21 Paint the foreground pool with the no. 10 brush and a mix of French ultramarine and burnt umber, sweeping across and leaving speckles of white. Use a damp 13mm (½in) flat brush to lift out some colour with horizontal strokes. While this is wet, put in dark reflections and pull out ripples in the reflections with the flat of the brush.

22 Strengthen the background behind the right-hand tree with the no. 4 brush and French ultramarine and burnt umber. Use the no. 10 brush to paint the area in the lower right-hand corner of the painting with yellow ochre.

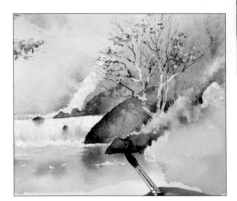

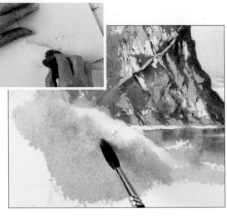

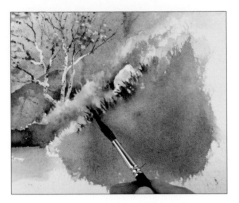

23 Wet the area to the left of the cascade with the no. 7 brush and touch in a pale wash of French ultramarine and burnt umber to define the edge. Soften with a damp brush. Strengthen the rocky edge of the bank on the right with a stronger mix of the same colours and drop in cadmium yellow pale.

24 Tear a piece of card or spare watercolour paper to form a paper mask and use a sponge to lift out a rock shape at the bottom left. Blot the rock with paper tissue then use the no. 7 brush with French ultramarine and burnt umber to paint the rock, and drop in cadmium yellow pale to suggest lichen.

25 Paint a wash of burnt umber and French ultramarine over the right-hand bank to suggest texture. Do not add too much detail towards the edges of the painting as you want the eye to be drawn to the focal point rather than here. Paint a little vegetation with a strong mix of burnt umber.

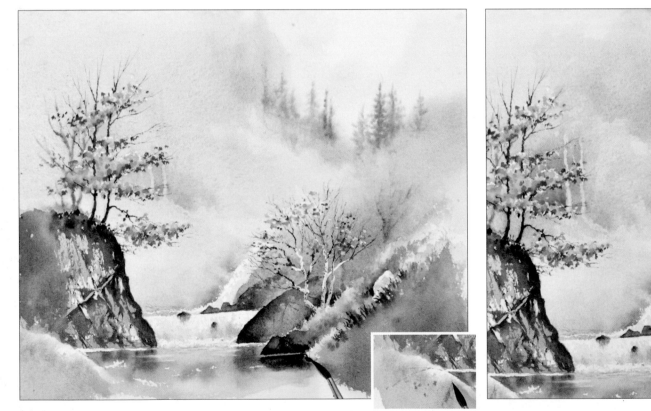

26 Reinforce the edge of rock at the water's edge with French ultramarine and burnt umber. Add fracture lines with the point of the brush. Wet the area of water below this and paint in the reflection with the same mix. Suggest texture and fracture lines in the rock at the bottom left with a pale mix of the same colours.

27 Wet the central background area and extend the negatively painted tree trunks upwards with French ultramarine and burnt umber. Accentuate the mist by adding darker shades behind it. Soften any hard lines with a damp brush. Add the hint of a distant bank.

The finished painting. At the final stage I added a little texture to the area at the bottom right with burnt umber and cadmium red.

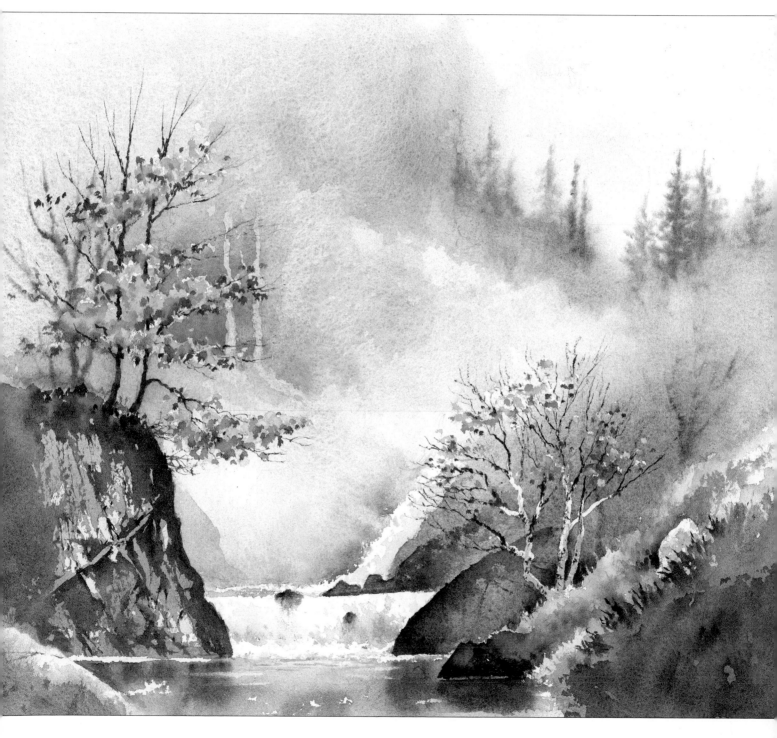

Index

The Needles

This simple watercolour sketch was carried out on cartridge paper. The Needles and cliffs of the Isle of Wight were barely visible through the evening atmosphere. In translating this into a painting I would make the Needles stand out more and probably introduce a small white sail against the dark cliff to their left.